UNDERWATER
GHOST TOWNS OF
NORTH GEORGIA

Lisa M. Russell

THE
History
PRESS

Published by The History Press
Charleston, SC
www.historypress.net

Front cover, top: Map. *Library of Congress*; *bottom*: *pseabolt, via Wikimedia Commons.*

First published 2018

Manufactured in the United States

ISBN 9781467139847

Library of Congress Control Number: 2018940075

For Josie Brooke Russell
May your precious heart be as free as the wild rivers of North Georgia

In writing Underwater Ghost Towns of North Georgia, *Lisa Russell shares her love of uncovering history, connecting land and people with legacy. Russell closes with a vision of a future that would not attempt to ignore past mistakes, nor rewrite history, but challenges us to look toward new solutions that would leave our wild rivers free.*
—Jackie Cushman

Just before the impounding of Carters Lake, a paddler making his way down the Coosawattee River saw an old-timer fishing on the bank. "They biting today?" the paddler asked. "I don't know yet," the fisherman replied. "But they're messing up a mighty pretty river." Georgia lost many pretty rivers in the twentieth century. We're familiar with the touted benefits: flood control, water storage, and recreation. In Underwater Ghost Towns of North Georgia, *Lisa Russell shows us some of what we lost: beautiful rivers, tranquil valleys and rich natural and human history.*
—Dan Roper, editor, Georgia Backroads *magazine*

CONTENTS

CONTENTS

PREFACE

Once upon a time, the rivers were wild. Communities built up around the unruly North Georgia waterways while farmers eked out a livelihood in fertile river bottom lands composed of red chocolate soil. Described by explorers and poets like Bartram, McPhee, Reese, Dickey and Lanier, the rivers seemed for a moment mythical and sensuous. This book was not drafted as an environmentalist argument but rather a review of drowned towns. The goal was to surface ghost towns and remnants of places ravaged by the impoundment. This work has been an unexpected adventure with swift switchbacks and undertones of ambiguity. The journey caused a question to surface. "What if?"

What if the rivers continued to flow? What if we developed alternative ways to harness electricity? Was the damage to terrain and community worth it? While the impoundment destroyed towns, the same dams prevented devastating floods in Rome and Gainesville. Artists try to capture place. Place is not only a physical description, it also involves cultural and psychological elements. These stories attempt to portray a place in the life and words of those who lived through the radical changes to their mountain land. Ponder the past as we visit the lakes.

THE POETRY

In the 1700s, William Bartram had to delay his trip back home to Philadelphia. He scribbled in his diary that "this circumstance allowed me time and opportunity to continue my excursions in this land of flowers."[1]

Bartram, a botanist, explored North Georgia and recorded the beauty of the rivers and the flora on the banks with poetic words. His records left a snapshot of a distant memory.

After the Civil War, Sidney Lanier traveled the hills of North Georgia and composed "Song of the Chattahoochee." He drew attention to the region's simplistic beauty, reflecting on a place that no longer exists. This was Lanier's favorite poem:

"THE SONG OF THE CHATTAHOOCHEE"

Out of the hills of Habersham,
Down the valleys of Hall,
I hurry amain to reach the plain,
Run the rapid and leap the fall,
Split at the rock and together again,
Accept my bed, or narrow or wide,
And flee from folly on every side
With a lover's pain to attain the plain
Far from the hills of Habersham,
Far from the valleys of Hall.

All down the hills of Habersham,
All through the valleys of Hall,
The rushes cried Abide, abide,
The wilful waterweeds held me thrall,
The laving laurel turned my tide,
The ferns and the fondling grass said Stay,
The dewberry dipped for to work delay,
And the little reeds sighed Abide, abide,
Here in the hills of Habersham,
Here in the valleys of Hall.

High o'er the hills of Habersham,
Veiling the valleys of Hall,
The hickory told me manifold
Fair tales of shade, the poplar tall
Wrought me her shadowy self to hold,
The chestnut, the oak, the walnut, the pine,
Overleaning with flickering meaning and sign,
Said, Pass not, so cold, these manifold
Deep shades of the hills of Habersham,
These glades in the valleys of Hall.

And oft in the hills of Habersham,
And oft in the valleys of Hall,
The white quartz shone, and the smooth brook-stone
Did bar me of passage with friendly brawl,
And many a luminous jewel lone
Crystals clear or a-cloud with mist,
Ruby, garnet, and amethyst-
Made lures with the lights of streaming stone
In the clefts of the hills of Habersham,
In the beds of the valleys of Hall.

But oh, not the hills of Habersham,
And oh, not the valleys of Hall
Avail: I am fain for to water the plain.
Downward the voices of Duty call-
Downward, to toil and be mixed with the main,
The dry fields burn, and the mills are to turn,
And a myriad flowers mortally yearn,
And the lordly main from beyond the plain

In 1953, the "valleys of Hall" would become Lake Sidney Lanier.

THE LEGACY

Looking at the North Georgia lakes requires looking in the past through the eyes of those who walked the land. The aim is to tell the people's story. To look at remaining scars on the mountain community.

Famed writer John McPhee took a wild trip in the 1970s across Georgia. He experienced back roads and the Chattahoochee River:

> *The Chattahoochee rises off the slopes of the Brasstown Bald, Georgia's highest mountain, seven miles from North Carolina, and flows to Florida, where its name changes at the frontier. It is thereafter called the Apalachicola. In all its four hundred Georgia miles, what seems most remarkable about this river is that it flows into Atlanta nearly wild. Through a series of rapids between high forested bluffs, it enters the city clear and clean. From parts of the Chattahoochee within the city of Atlanta, no structures are visible—just water, sky, and woodland. The circumstance is nostalgic, archaic, and unimaginable....Atlanta deserves little credit for the clear Chattahoochee, though, because the Chattahoochee is killed before it leaves the city.[2]*

On this same trek across Georgia, McPhee took a canoe trip with then governor Jimmy Carter. Carter said while on the Chattahoochee in 1973, "We are lucky here in Georgia that the environment thing has risen nationally, because Georgia is less developed than some states and still has much to save."[3] Returning to the governor's mansion, McPhee recorded Governor Carter saying, "The river is just great, and it ought to be kept the way it is. It's almost heartbreaking, the destruction."[4] He must have been affected by the trip down the Chattahoochee. Later, Carter stopped the damming of the Flint River.[5]

James Dickey made the North Georgia rivers infamous. McPhee described a film location on the Tallulah River: "Some twenty miles on down, the river had cut a gorge, in hard quartzite, six-hundred feet deep. Warner Brothers had chosen the gorge as the site for filming of a scene from James Dickey's novel, *Deliverance*." The area was labeled "Deliverance Country."[6]

McPhee went to the "climb-out scene" and saw Tallulah Gorge as it remains today:

> *The six-hundred-foot gorge was a wonder indeed, clefting narrowly and giddily down through the quartzite to the bed of the river that had done the cutting. Remarkable, though, no river was there. A few still pools. A trickle of water. Graffiti adorned the rock walls beside the pools. There was a dam nearby, and, in 1913, the river had been detoured through a hydropower tunnel.[7]*

Most of *Deliverance* was not filmed at Tallulah Gorge but on the Chattooga River. Chattooga is one of the few remaining white-water rivers in Georgia. The film could not be made in the location that inspired it.

Carters Dam had already tamed the Coosawattee and formed Carters Lake. The sad legacy of the film is not how progress killed the wild rivers of Georgia but how the movie damaged the mountain people's dignity.

McPhee described the people of the mountains as "malevolent, opaque, and sinister."[8] Dickey's words in *Deliverance* were a degrading and a poor depiction of the residents. Former Foxfire student Barbara Woodall, taught to respect their culture and society, researched the impact of the filming of this movie. Besides damaging local lands, such as digging up a potato patch with little compensation, the scar is much more personal.

A few locals were given small roles, but they did not know what was happening as the cameras rolled. Woodall said, "Area resident Nell Norton, known as 'Whispering Nell' because she was a very vocal gal, appeared in a dining room scene. 'They didn't tell me what the movie was about. They said they'd like to take my picture. They said they would like to have me in the movie. They didn't tell me nothing.' They picked the boy as the banjo player not because he could play (he could not) but because he fit Dickey's description of a 'splay-eyed boy.'"[9]

Woodall defended her view and pointed out Dickey's degrading depictions:

The sort of men you mock, but at the same time are relieved to be rid of. The sort of men that are "creatures" from whom you expect nothing but mean words and know if you see them in the woods are tending their still. The sort of men who jump like dogs on their hind legs, or who are "albino" or splay-eyed or "demented" or worse. A land of men, "ignorant and full of superstitions and bloodshed and murder and liquor and hookworm and ghosts and early deaths." (46). A land so depressingly base that the "I" of the novel can say, and believe, "Nobody worth a damn could ever come from such a place."[10]

Deliverance was built on the premise that the government was going to destroy the white water by building a dam. In arrogance, the movie denigrated the mountain people by branding all of them as hicks, moonshiners, ignorant and hopeless.

The Sacredness of Place

I did not start out writing this book about conservation or preserving natural Georgia. I was confronted with the land that once was and the people who were affected. The overall significance of this story is *place*.

Place is significant beyond physical location. More than what once was, place is an impression of the past. Place is central to the characters of the story, the people. The people of North Georgia are wed to the land—for better or worse. The place is a character in this story. Place has purpose and meaning. Place is sacred.

Fellow graduate student and now colleague at Kennesaw State University Christopher Martin wrote this about place and North Georgia "Place is important in writing, and some places are sacred."[11] Martin is a poet and naturalist. Of Georgia poet Byron Herbert Reece, he wrote:

> *From the slopes of Blood and Slaughter Mountains, Wolf Creek flows beneath green veils of rhododendron into the Nottely River, creating a narrow valley bounded by some of the highest peaks in Appalachian Georgia. It was here in 1917, amid the fertile bottomland of creek and river and mountain shadows, that the poet Byron Herbert Reece was born.[12]*

Reece understood the sacredness of place when he wrote:

> *I stood in paradise, no land of thrones*
> *Nor of streets of gold, nor of harps, nor of jeweled halls,*
> *Alone, unchallenged, in a place of stones—*
> *Suitable setting for such a quiet as falls*
> *On him just entering. With eager eyes*
> *I looked, and saw the place to which I came*
> *Was my own land…*
> *—Byron Herbert Reece, "On Dreaming of Ascending to Paradise on Foot"[13]*

Remain true to the place. Wendell Berry leaves these lines as a boundary:

> *Stay away from anything*
> *that obscures the place it is in.*
> *There are no unsacred places;*
> *there are only sacred places*
> *and desecrated places.*
> *—Wendell Berry, "How to be a Poet"[14]*

I do not want to get in the way of the place in these stories of what lies beneath the great lakes of North Georgia. I will let them speak for themselves and tell their history and their future. These places deserve our respect by listening. It is up to the reader to decide if these places remain sacred or if they have been desecrated.

Acknowledgements

I am a tree climber. Bruce Ballenger in his text, *The Curious Researcher*, says, "As researchers, we're tree climbers, standing on branches that other researchers before us have grown. A citation identifies the wood we're standing on that has helped us to see further into our topic."[15] I have stood on lots of branches to see farther than I could have on my own. Here are the branches (the scholars) where I climbed to further my research and write this book:

- Drs. Mary Lou Odom, Laura McGrath, Linda Neimann and Elizabeth Giddens for giving me the tools to write.
- The late E. Merton Coulter, great Georgia historian, who recorded things no one else did.
- Dr. Katherine Thompson for your insight, research and amazing photographs of Blue Ridge.
- Robert David Coughlin, *Lake Sidney Lanier: A "Storybook Site."* This book is heavy with valuable information. Thank you for all your time and support.
- Jim Langford for speaking at the Etowah Valley Historical Society about the region.
- Dr. Heidi Popham at Georgia Northwestern Technical College for the opportunities.
- Marty Moorehead for your tips on *Wild River* and your interest in this project.

- The National Archives in Atlanta staff.
- Dr. Fred Roach, my graduate history professor, who taught me how to do quality research.

I have to thank my husband, who for over thirty years has managed to put up with me. Your help with this book was invaluable. The years you dragged me to the North Georgia lakes and rivers had a bigger purpose. This book would be dedicated to you if not for the arrival of our second grandchild, Josie Brooke. Our granddaughters are the blessing of our long marriage.

Thank you, Michael and Becka, for giving us another granddaughter. It has been great to have you as housemates and watching your dream home rise as you await the little one's arrival. Josie Brooke, this book is yours. Michael, your love for hunting and fishing along the Georgia lakes inspired many lines.

Samuel, your help in the archives was crucial to getting this book finished. You have always been there to support your mother. I am proud of you for the man you are and what you have ahead.

John, you have been the best research assistant/fact-checker. I am grateful. You are a good daddy and a dedicated servant. Follow your calling with your whole heart. Laura Leigh, thank you for copyediting and for the gift of Charlotte.

I have two sisters I must thank. The one I was given by birth and the one who my heart was knit to—Ellen and Ella. You both have been my mental support and saved my life in so many ways.

To my work family, the girls on the hall who always are interested in my writing projects: Beth, Faith, Kathy, Ally, Bee, Steph and Jan—thank you. Ronda and Jodie, you are great deans and supportive of your faculty; you will never know what that means to your instructors.

Finally, my life belongs to my first love, Elohim. My Creator and the Creator of the majestic mountains and rivers of North Georgia.

Appreciation to:
The Army Corps of Engineers
Tennessee Valley Authority
Etowah Valley History Society
New Echota Historic Site
David Gomez
Bartow History Museum
Rabun County Historical Society

Acknowledgements

Dogwood Books, Rome, Georgia
Kenneth Studdard
General Mercantile, Adairsville, Georgia
Carol Robson
Cracker Barrel in Cartersville and Canton, Georgia
Funk Heritage Center at Reinhardt University
Dr. Donna Little-Coffee, Reinhardt University

Introduction

David is a Georgia boy with cracklin' cornbread on his breath and red clay under his nails. In 1984, a few months after we married, we loaded up the truck to visit my homeland, Western New York. Born in Buffalo and raised in the country near East Aurora and Orchard Park, I spent my summers on Lake Erie. Going to Aunt Edna's was magical but also militaristic.

Aunt Edna ran her little cottage like a boot camp—we called her "Serge." She ran a tight ship. The magic was the lake, the water. I didn't mind the dead fish floating. It was the polluted era better known as the 1970s. I thought it was normal, which explains my aversion to seafood. I found freedom and peace every summer at Lake Erie.

I wanted David to experience Lake Erie and Aunt Edna. We had a full itinerary, but I knew where I wanted to go first. We bumped along the oiled roads in the Seneca Nation near Snyder Beach. My husband approached the tiny white cottage with green shutters. The banner stretched across the front read, "Welcome Home." It was nice to be welcomed, but it had not felt like home in years. North Georgia was my home.

El Niño had changed the shoreline to a tiny sliver of driftwood and lake rocks. The lake had changed—it was clean. The lake had healed itself—the pollution was gone. The beach had disappeared along with the pollution; a trip down the beach was a rocky hike. I walked along the edge of Lake Erie with my Aunt Edna and reminisced about growing up at her cottage.

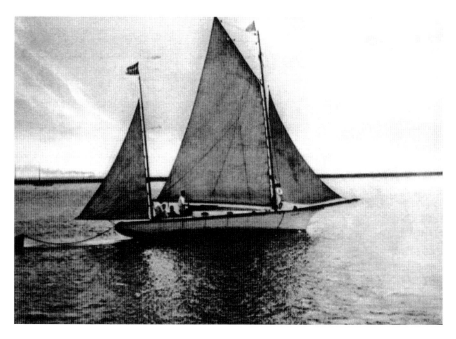

Yachting on Lake Erie, Buffalo. *Author's collection.*

When we got back to our North Georgia home, it was interesting to hear my husband's impression of the trip. He commented on two things. He told his friends about Aunt Edna's shrimp cocktail: "They poured shrimp and sauce over a block of cream cheese." The biscuit-eater was confused about the combination of shrimp and cream cheese. He was more perplexed about the great lake. He commented on the size of Lake Erie: "You can't see the other side!"

I had never thought about it. My husband hunted, camped, swam and fished on reservoirs or human-made lakes. He watched workers carve out the deep hole that became Carters Lake. He knew the land before the lake, the wild North Georgia rivers like the Coosawattee, Chattahoochee, Toccoa and the Etowah. He never questioned the sequestering of these natural waters; it was what it was. It was his outdoor childhood.

My husband, David, has introduced me to most of the lakes of North Georgia. I fell in love with the lakes. Sitting on the shore at Blue Ridge Lake, I could see the other side. It was not the lake of my childhood, but to me it was still a great lake. We camped with our sons along many North Georgia lakes, and they spent hours fishing on even more of them. One of my favorite

things is sitting on the banks and soaking in the peace that these waters bring. However, writing this book has changed my feelings about the lakes of North Georgia. I look at them differently, now that I know their true story.

While searching for lost places in my first book, *Lost Towns of North Georgia*, I found some drowned towns under those lakes. These sites were sacrificed for progress, as the U.S. Army Corps of Engineers, TVA and Georgia Power flooded them to form a lake. When I wrote my chapter "Drowned Towns," I only wrote about actual towns, but there is so much more to the story and more places to revisit. Without the restrictions of finding towns, I could explore what lies beneath.

Not every lake in North Georgia has a town underneath. Few established entities with zip codes and town halls existed in the flooded regions. Instead, isolated, ill-formed communities were the norm. The communities consisted of farming villages, gas stations or racetracks. Businesses picked up and moved. Houses were pulled from their foundations and loaded on the back of flatbed trucks. Workers lifted bodies to higher ground, leaving empty cemeteries.

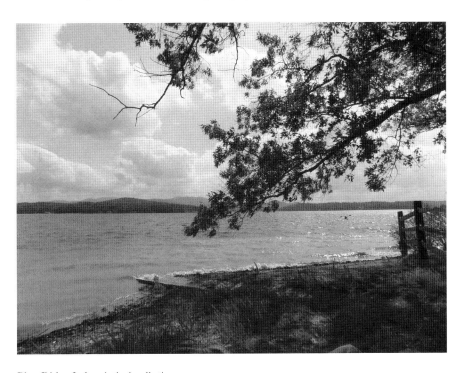

Blue Ridge Lake. *Author's collection.*

Imagine a time when not one natural lake existed in North Georgia. Erase the lake before you and replace it with a valley and a river. Envision the farmer and his family. Try to think about the churches and their dead before reinterment, the animals and hunting grounds now replaced with stocked fish. All of these things were relocated by government decree for a state hungry for power and control. The New South needed power, and the lowlands required flood control. The solution was to cut off the aggressive rivers and build a dam across. Something wild was lost in the process. The original naturalness of North Georgia is gone.

As we visit these lakes, imagine floating in the middle, leaning over and staring deep into the murky, green waters. Look long enough to see the *Underwater Ghost Towns of North Georgia.*

While not every lake in North Georgia is mentioned in this book, the story is repeated at each reservoir. This is a biography of a region transformed by perceived needs. This tale is a memoir of the rivers forced into unnatural reservoirs tamed for progress—maybe for the better, maybe for the worse. What is in the future? Will more rivers be tamed and fake lakes created? That part of the story is yet unwritten.

THE LAND BEFORE THE LAKES

THE DIFFERENCE BETWEEN
GOD-MADE AND HUMAN-MADE

S ir James Wright, the third and last of Georgia's royal governors, wanted to settle the land. So, in a 1772 trip to England, he hoped to attract new settlers to the state. Thus, he produced brochures promising safe and secure land for each family. In 1793, Bartram expanded on Wright's description of North Georgia: "a body of excellent and fertile land, well-waters by innumerable rivers, creeks, and brooks."[16] Rivers once defined Georgia's landscape. Reservoirs or human-made lakes may irritate the environmentally aware. However, the UGA River Basin Science and Policy Center asserts, "Georgia's streams and rivers have shaped the state's development while supporting a rich biological heritage."[17] The state boasts 269 different freshwater fishes—only Tennessee and Alabama have a larger variety. North Georgia had no major natural lakes. North Georgia has reservoirs. A reservoir is an artificial lake stored behind a dam that has blocked the natural-flowing water. In the early 1900s, Georgia constructed dams for hydropower, flood control and water navigation. Recreation was an afterthought.[18]

Reservoirs appeared in the early 1900s when the Georgia Power Company impounded waters for use as cooling structures for coal-fired electrical plants and hydropower. Tennessee Valley Authority, for flood control and power, created reservoirs in the 1930s. The U.S. Army Corps of Engineers constructed dams in Georgia for navigation and flood control in the 1940s and 1950s under the Flood Control Act of 1944 and the Watershed Protection and Flood Prevention Act of 1954.

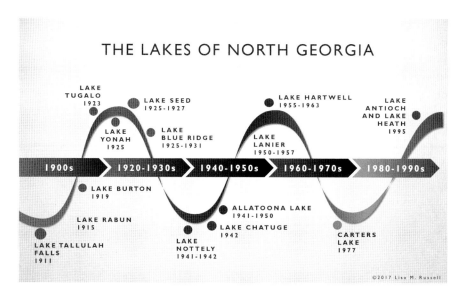

The lakes of North Georgia through the years. *Author's collection.*

Power continues to be a need, but water supply is an issue. While the Georgia Power Company and the Corps of Engineers impounded rivers for power and flood control into the 1980s, new reservoirs have a different purpose. Georgia droughts highlight the need to increase local water supply. A water crisis in Georgia may show the need for more dams. Sonny Perdue, who stood on the state capitol steps on November 13, 2007, begging God to end the drought, was not the first governor to pray for rain. In the 1950s, Governor Herman Talmadge led a Sunday service designated as a "day of prayer for rain."[19] Georgians had to handle their water woes. The Georgia Water Use and Conservation Committee promoted water conservation and wise use, and the general assembly found other ways to settle the water trouble. Lake Hartwell and Clarks Hill Lake (later known as Lake Strom Thurmond) were the solution. Hartwell had many land condemnations, but the Corps completed the dam, and the lake filled by 1962.

Man-made lakes require fairly regular maintenance to keep them up. According to the UGA River Basin Science and Policy Center, many of the smaller dams built under the Flood Control Act of 1944 and the Watershed Protection and Flood Prevention Act of 1954 by the U.S. Department of Agriculture require repair. They are at the end of their fifty-year lifespans.[20] The bigger North Georgia impoundments were built differently.

The land underneath these waters was left intact. Most of the trees, standing vegetation and building remnants were submerged with the rising waters behind the dams. Underwater landscapes differ. Smaller dams required liners of fabric or compacted clay to prevent water loss. Larger and newer impoundments provided habitats for fish. People are encouraged at some lakes to deposit their Christmas trees to add to the ecosystem.[21] There is a difference in how they hold water and what lies beneath the water.

Constructed lakes differ from natural lakes in several significant ways. According to the UGA River Basin Science and Policy Center, "The drainage basins of reservoirs are typically much larger than the lake surface area and the drainage basins of natural lakes. Reservoir basins tend to be narrow, elongated, and dendritic (branching) because they are most commonly formed in river valleys."[22] A bird's-eye view of most North Georgia reservoirs proves this point. Lake Lanier is a good example with its long crooked fingers of water flowing out from the huge bodies dotted with tiny islands.

The runoff from streams and rivers is "not typically intercepted by wetlands or shallow interface regions. The result is that runoff inputs are larger, are more closely linked to rainfall, and affect a larger portion of the lake than is the case in most natural lakes. These characteristics lead to high inputs of nutrients and sediments in rainy weather."[23] Natural lakes have lower nutrient and sediment concentrations because they are located at the headwaters, while reservoirs are at the mouth of rivers and streams.

The constant change of water levels in constructed lakes and the water release from the bottom affect the quality of water downstream. Scientists noted that "[r]eservoirs frequently release water from the bottom of the dam pool, which contains little-dissolved oxygen; this may cause problems with water quality downstream. Natural lakes, in contrast, typically release well-aerated surface waters." Natural lake levels are consistent.[24] The changing levels of controlled waters cause other ecological differences.

Reservoirs and natural lakes differ in shape and size. Different plants grow, and diverse animals flourish in each body of water. Human-made lakes are stocked with fish for sport fishing, and these fish develop a variant food web. Stock fish are inhibited in reservoirs due to lack of flowing water; native fish cannot naturally reproduce.

Biologists at the University of Georgia warn,

The reduced flow velocity and increased sediment loading can suffocate native mussels and other bottom-dwelling species; for this reason, many

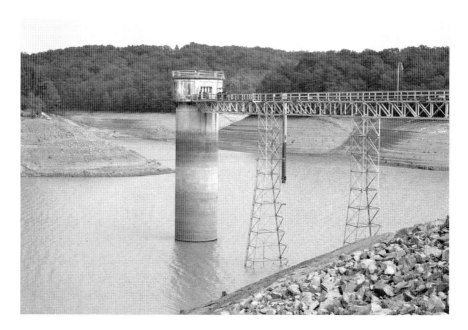

Lake Blue Ridge's 192-foot concrete intake tower during drawdown. TVA gradually lowered the water level to an elevation between 1,620 and 1,630 feet above sea level. *Courtesy of Dr. Katherine Thompson.*

of Georgia's native mussel species are now in danger of extinction. The differences in flow and sediment also alter the base of the food web to one of the suspended algae (phytoplankton), rather than the attached algae (periphyton) and detrital material that form the food base in rivers and streams.[25]

Muir's Musings about Southern Streams

When John Muir made his *Thousand Mile Walk to the Gulf*, the Chattahoochee and the Savannah Rivers flowed freely through North Georgia and he was drunk with the "intoxicating banks."[26] Muir wrote:

September 23 Passed the comfortable, finely shaded little town of Gainesville. The Chattahoochee River is richly embanked with massive, bossy, dark green water oaks, and wreathed with a dense growth of muscadine grapevines, whose ornate foliage, so well adapted to bank embroidery was enriched with other interweaving species of vines and brightly colored flowers. This is the first truly southern stream I have met.[27]

Less than one month later, Muir encountered a plantation owner near Savannah and begged for a place to sleep. After a night of botany discussions, the topic turned to how the river waters would be used in the future:

> *"Young man," he said, after hearing my talks on botany, "I see that your hobby is botany. My hobby is e-lec-tricity* [sic]. *I believe that the time is coming, though we may not live to see it, when that mysterious power or force, used now only for telegraphy, will eventually supply the power for running railroad trains and steamships, for lighting, and, in a word, electricity will do all the work of the world."*[28]

Muir mused later, "The vision of this Georgia planter, so far in advance of almost everybody else in the world. All that he foresaw has been accomplished, and the use of electricity is being extended more and more every year." Muir saw the beauty of the North Georgia rivers and, on the same journey, discovered how those rivers would power the future.

PART I

THE ARMY CORPS OF ENGINEERS LAKES

1

THE ARMY CORPS OF ENGINEERS

The U.S. Army Corps of Engineers (USACE) improved navigation on U.S. waterways. It has served as part of the army since the American Revolution. The Continental Congress organized the Corps to assist General Washington, and the organization is still part of the U.S. Army.[29]

The USACE, named in 1802, had a larger mission between 1900 and the 1930s, flood control. The Corps was required to benefit the national economy and include waterway navigation. While the Corps manages hundreds of multipurpose dam projects today, it ambled along in 1918 with its first hydroelectric project at Muscle Shoals, Alabama. Thus began the big dam era for the Corps.[30]

The USACE and hydroelectric power helped usher in the New South. The government infused the agrarian economy with federal monies to build up the region beginning in the Depression through World War II. The South Atlantic Division (SAD) of the USACE has four major themes, according to *The History of the South Atlantic Division of the US Army Corps of Engineers, 1945–2011*: military support, environmental protection and restoration, civil works and management leadership.[31] Mistakes were made over the fifty years, but the USACE was steadfast in its mission of flood control, hydroelectric generation and navigation. The original purpose of the Corps was not to ensure water supply or create places for recreation, but those undertakings grew in importance.[32]

After the USACE built and supplied the war effort and helped with a postwar deconstruction of military installments, it returned to its first love

of water control. Postwar Georgia, along with the rest of the Southeast, took baby steps toward environmental concerns, and the Corps moved to a more balanced approach. Environmental issues and economic benefits were growing concerns. Increased water use and environmental impact became obvious in the 1960s and 1970s. No major construction in the South Atlantic Division has been planned for over twenty years. The Corps now focuses on maintenance and environmental restoration.

The USACE began building dams and forming reservoirs in Georgia for navigation and flood control in the 1940s and 1950s under the Flood Control Act of 1944 and the Watershed Protection and Flood Prevention Act of 1954.[33] The reasons for the dams and lake have evolved. In 1950, Allatoona Dam was the first USACE project completed in North Georgia. It was followed by the Clarks Hill project in 1953, later renamed for J. Strom Thurmond. Lake Sidney Lanier began and was completed in 1957 with great pomp and circumstance. Lake Hartwell was filled with controversy in 1962. Carters Lake, the deepest Georgia lake, delivered the area from flooding in 1977. The Corps stopped building dams in 1985.

Just as the USACE evolved from a navigation and building wing of the U.S. Army, the reservoir projects changed in scope and purpose. *The History of the South Atlantic Division of the US Army Corps* stated, "No attention was paid to adverse effects to the land or fish and wildlife except as it involved a federally protected preserve."[34] The division had specific objectives: flood control and regional development. The USACE outsourced jobs that did not fit the mission. Archaeologists were hired to relocate cemeteries. The forestry division was utilized. The Corps saw no need to focus on biology, archaeology or forestry.[35]

Ignorant of the environmental impact of human-made lakes in the 1940s and 1950s—when most of the work was completed—in more recent years, the Corps has become environmentally responsible, reversing any damage caused by these reservoirs. The USACE also has cooperated with the more recent looter's law protecting the historic remains when drought pulls back the waters and exposes lost communities. Steep fines discourage relic hunters from scavenging the lakes' secrets.

Without breaking any laws, let's dive deep into each lake and the communities that once thrived under the lakes managed by the U.S. Army Corps of Engineers. Imagine a time in the ghostly past when North Georgia was filled with natural rivers and the souls who once thrived along the banks.

2
ALLATOONA LAKE

1950

History-minded Georgians and visiting historians from other States are preparing today for a final pilgrimage to a soon-to-be-submerged land where some of the lustiest, liveliest dramas of the past were played out.
—Celestine Sibley

Allatoona has more identifiable towns underneath its waters than all the great lakes of North Georgia. Remnants of the lost towns of Etowah and Allatoona lie above the water line. Until recently, Abernathyville was hidden. The Etowah Valley Historical Society has unearthed the existence of a community that lies just off the shores of the lake. Abernathyville lies just below the Old Macedonia Cemetery in Bartow County. Allatoona has been the subject of archaeological studies that reveal a civilization that predates these forgotten towns.

ABERNATHYVILLE
(OLD MACEDONIA COMMUNITY)

He uncoiled the cords that guarded his weathered wallet and paid the man at the *Cartersville News*. He apologized, "The cold weather has kept me in, or I would have been down earlier to settle my subscription." The seventy-eight-year-old bewhiskered Bardy Larkin Abernathy sat down on a bright

March morning in the newspaper office and bragged, "I was one of the first subscribers to the newspapers in this town." He continued, "I took the old *Standard and Express* and all of the papers that have come on after it right straight along to now, and I can't begin to do without your paper, that is right up to the times."

The news staff plied him with more questions about being among the early settlers of Bartow County, then known as Cass. In 1836, Abernathy's father moved his family from Lincoln County, North Carolina, about three hundred miles of rough terrain, "never crossing a railroad track and forded nearly all the rivers as we found only two or three bridges over streams on the whole trip."

Abernathy, a Primitive Baptist preacher, explained that the "Indians had just gone, and we could see their bark shanties they had left in the woods. There were only pig trails over most of the territory around here, and human habitations were far apart."

The inquisitors continued to ask him questions, "Living near them, you knew the old Cooper Works on their better days[?]" Reverend Abernathy answered by detailing how people would come and buy iron and cookware before the Civil War. During the war, the Confederate government contracted for cannons and cannonballs. He reflected on the appearance and how the weapons were "turned loose on the Yankees to their great sorrow, I reckon."

Abernathy, knowing he could talk away the day about a place he once knew, returned his corded wallet to his pocket and went out the door but looked back and said, "Send me up some writing material, and I will tell you more stories from the Macedonia settlement where lots of Abernathys live." It was 1904.

The *Cartersville News* followed up with Elder Bard Abernathy six years later to report about his ten-month confinement from a fall and hip displacement. The *News* reported on his temperament: "No picture of pious resignation we have ever seen has equaled that which Mr. Abernathy displayed as he lay on his bed recently and talked so calmly and cheerfully to those around, never murmuring because of the confinement and suffering he had to endure, merely saying that those possessing good health should appreciate such a blessing."[36]

The newspaper called him one of the most "interesting figures in Bartow County's history. When he came to the area as a 9-year-old boy, the Western & Atlanta was under construction; he even helped lay the track."[37] He bought forty acres and lived in the community for seventy-two years before his death in 1914.

Elder Bard Larkin Abernathy was part of the Abernathyville community and is now buried in the Old Macedonia Cemetery There were many Abernathys, but there were also markers with the prominent names of Summey, Atkinson, Keever, McGhee, Blackburn, Cox, Dellinger, Howell, Tidwell and many others. The community nicknamed "Abernathyville" now resides beneath the murky green waters of Lake Allatoona

Abernathyville was lost to history before it was lost to the lake. Joe Head and the Etowah Valley Historical Society maintain an interactive map of communities at the Etowah Valley Historical Society map gallery.[38] The map exposes areas lost to impoundment in the 1940s. One town that was unheard of until recent years was personal to Joe. He is an Abernathy.

The town was named for the large family, but it may be a nickname because the Macedonia community was built from the Stamp Creek District. The locals say that Abernathyville existed before the Macedonia Community. Once the Macedonia church was established, its neighbor, Abernathyville, surrendered its significance.

The cemetery was dedicated in the mid-1800s, and the first burial was Lintford Abernathy's child. Lintford later donated the land to the church. The church was built following the cemetery, and the area became known as Macedonia. Inserts of the Macedonia school prove the town existed. On the banks of Allatoona Lake, this cemetery was saved from the flood waters, although it feels ominously close to the edge and some graves seem ready to slide in.

As early as the 1920s, the Georgia Power Company began plotting to dam up the Etowah River for hydroelectric power production, but the Great Depression ended those plans. In 1941, the Army Corps of Engineers began preparing the land for impoundment.

The land was purchased while workers dismantled the structures and homes in preparation for the coming waters. Macedonia assumed the graves were to be moved. Many cemeteries were condemned to rest on the bottom of the lake, including the famed industrialist Mark Anthony Cooper and family. However, in 1946, the Army Corps decided not to move the graves at Old Macedonia Cemetery. They built a new road. The old road to Macedonia (Abernathyville) was drowned.

Now the cemetery is cared for by the loving families, descendants of the pioneer town of Abernathyville and Macedonia. The remote area slopes down to the water's edge, as if holding on as not to slip in and join the drowned town.

Driving down the desolate road that ends at Old Macedonia Cemetery, you wonder how many families once covered these red hills so close to the Etowah

River. Arriving at dusk, the flickering of the lightning bugs is eerie. The light was marking the grave of a young man who died recently. His mother gave him a nightlight. The young death was likely tragic—as most are. The young soul, however, has a beautiful place to rest. He lies on the banks of Lake Allatoona surrounded by family and the warmth of an old lost community.

ETOWAH

A macabre scene was playing out. Men in dirty coveralls removed an oxidized iron casket from the family grave and laid it beside an identical one on a tarp. The USACE had just pulled the Iron Man of Georgia from Glen Holly, the family cemetery of the disappearing town of Etowah.

The mill city began and grew because of Mark Anthony Cooper. But now it was time to go. He was being moved across town to Oak Hill Cemetery. His family home and what remained of his village were about to be drowned by the waters of the Etowah River.

Across the lake from Abernathyville was Etowah. A single iron works pyramid is now the only remnant of this onetime center of Georgia industry and innovation. Long before the Civil War, Etowah prospered on the edge of the Etowah River. Not much remained of the town after the Civil War. So, repurposing this area for a lake was not as much a tragedy as it was for other North Georgia lost towns. Before Etowah drowned, a former resident remembered the ghost town.

Ninety-year-old Lillian Ray Bohannon Butler reminisced about her childhood. She was eight years old in the mid-1930s, living next to one of the old furnaces built by Moses Stroup and the only remaining structure from Cooper's Iron Works; the rest of the Etowah iron furnaces were destroyed during the Civil War. The family's milk cow roamed about the ruins of Etowah and came home at night. The animal was penned inside of the middle of the surviving furnace. When the cow did not return from grazing, Lillian's mother sent the little girl out. Lillian walked up the road to deserted Etowah. It felt like a ghost town, and it spooked her. She often found the cow in the old cemetery. Lillian guided the cow home and locked it in the iron furnace just as the sun faded.

Lillian remembered: "And wouldn't you know it, almost every time I would find that cow grazing in the tall green grass in the old cemetery. I always hated to go up there. It frightened me so! I was just a little girl."[39]

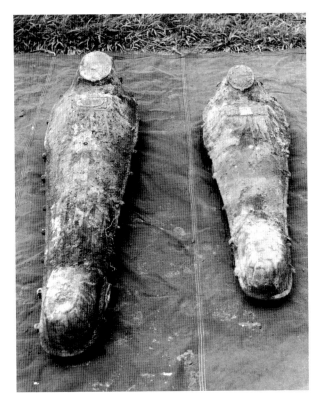

Left: Mr. and Mrs. Mark Anthony Cooper in their iron caskets as they are reinterred by the U.S. Army Corps of Engineers during the building of Allatoona Dam. *The Kurtz Collection, Atlanta History Center.*

Below: Etowah building ruins before the dam and after the Civil War. *Courtesy of Bartow History Museum.*

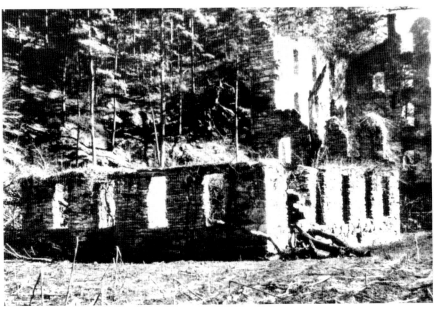

Etowah now resides at the bottom of Allatoona Lake in Bartow County, Georgia. All that remains is that one iron furnace, part of a day-use area that was once the centerpiece of a thriving industrial town. Moses Stroup and his father built the iron furnaces in the late 1830s. The first industrial park of Bartow (then Cass) County was located along the Etowah River. The industry was surviving, but it took an early industrialist to take it to the next level.

In 1847, Georgia congressman Mark Anthony Cooper and a financial partner, Andrew M. Wiley, purchased the furnace and many related businesses from Moses and worked together to build Etowah. The manufacturing town grew to two thousand people at its peak and contained a rolling mill, a flour mill, a carpenter shop, a foundry, spike and nail mills, a hotel and workers' homes.

Etowah had a spur track connecting to Western and Atlantic Railroad (W&A) that Cooper financed himself. The railroad had an engine called

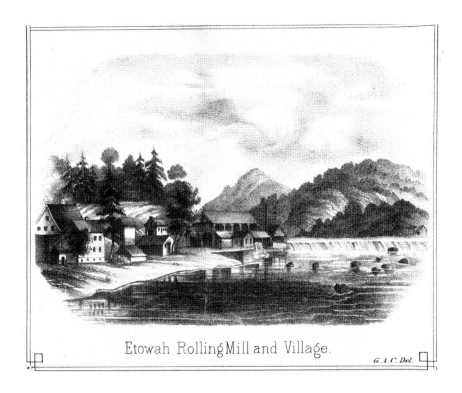

Etowah Rolling Mill and Village.

G.A.C. Del.

Etowah Rolling Mill and Village were destroyed during the Civil War, and any remains are at the bottom of Lake Allatoona, except one iron furnace on the banks of the Etowah River. *Courtesy of Bartow History Museum.*

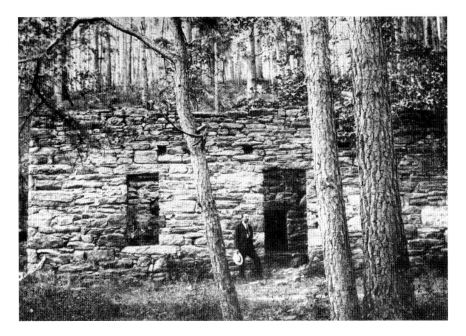

Crumbling building in old Etowah. *Courtesy of Bartow History Museum.*

Yonah. It not only shipped freight to Etowah Crossing—Yonah even played a role in the Great Locomotive Chase during the Civil War as well.

Cooper made and shipped pots, tools, cannons, spikes, nails, pig iron and other molded or rolled iron. The rails for Cooper's beloved railroad were first manufactured in Etowah. Many people worked to build this antebellum town, but it began with one man's passion for the land. He loved the land and the people. He fell on hard times and was rescued by his friends. He repaid those debts and went a step further. Cooper constructed a friendship monument thanking his debtors for helping him. When Etowah died, the residents moved the monument to the town square in Cartersville, where it remains to this day.

When the Civil War came to North Georgia, Cooper's ironworks were first used to supply the Confederate army. Eventually, Sherman's army rendered the works inoperable. Through a series of business transactions, Cooper lost ownership of the ironworks during the war. Cooper remained on his beloved Glen Holly after the war until his death on March 17, 1885. He was buried in Etowah's extensive cemetery along with his entire family.

The next phase in Etowah's life was the dam. The U.S. Army Corps of Engineers began working on the Allatoona Dam project in 1941, but due

to the world war, the project was stalled. In 1946, the work continued. By 1949, the dam was complete, and the waters began pouring into Etowah. The town was not salvaged, but Etowah had an extensive graveyard. Some graves in the town cemetery were moved; some remained. The Coopers had to be removed from Glen Holly.

A green copper plate at Oak Hill Cemetery tells the rest of the story:

> *In Memoriam*
> *This family cemetery containing eleven graves was removed from Glen Holly in 1949 to permit construction of Allatoona Dam and Reservoir. Erected by Corps of Engineers, U.S. Army*

Cooper and his wife now lie overlooking a former industrial area of Cartersville. A train rushes by their cemetery plot. Cooper, the champion for bringing the railroad to North Georgia, can hear his legacy.

After the reinterment of the Coopers, Lake Allatoona filled. Not all of Etowah's residents evacuated, and some remained. The cemetery in Etowah was so large and graves were unmarked. Portions of the old cemetery jut up on Goat Island in the middle of Lake Allatoona. The lasting monument on the grounds of old Etowah is Cooper's Furnace along the Etowah River behind Allatoona Dam.

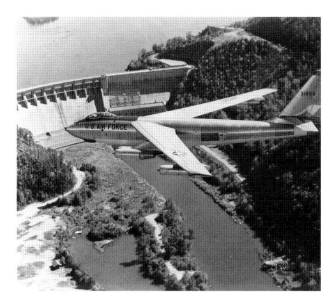

U.S. Air Force B-47 flying over Allatoona, 1950. *Atlanta Journal-Constitution Photographic Archives. Special Collections and Archives, Georgia State University Library.*

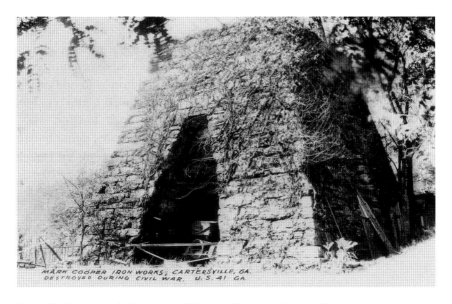

Cooper's Furnace in the lost town of Etowah, Georgia. *Author's collection*.

ALLATOONA

The Haunting of Allatoona Pass

The night was soaked with an inky darkness just seven years after the Civil War as the steam engine powered through Allatoona Pass on its way north. Just as the engine entered the pass, the W&A Railroad conductor noticed a soldier sitting on the top of the car. He climbed up into the darkness to collect the fare. The conductor walked toward the figure. Steps away, it disappeared. The soldier had melted into the night.

The disconcerted conductor reported to the engineer, "He was dressed in a soldier's uniform." Leaving the engine in the fireman's hands, the W&A engineer began to investigate. The moon was covered by a thick layer of clouds; the cool night left a mist in the air. Through the fog, the engineer saw a figure sitting on the top of the third car.

The engineer advanced on top of the train, his attention focused on the man sitting on his train. Sweat trickled down the engineer's back. He locked eyes with the gray shadow man. As he neared the transparent figure, it faded and then disappeared. The engineer searched the entire train and looked everywhere someone might hide. He climbed back on the top of the train and there the man was, sitting again on top of the train.

This time, the engineer marched in a quick step toward the ghost, but it disappeared again. The engineer walked back to the engine of the speeding train. Before he descended, the engineer glanced over his shoulder to catch a glimpse of the soldier back in his place. Cold air caused the engineer to shiver before he returned to relieve his fireman. The conductor kept watch and reported that the mysterious figure remained on the train for a few more miles, and then it was gone. Perhaps it was going to reenact this scene on the southbound train about to go through Allatoona Pass.[40] Ghost stories are just symptoms of what lies beneath the surface, what came before and what refuses to leave.

Allatoona Pass has a reputation. It's haunted. The unnatural cut into the mountain was the pass for nineteenth-century trains. The untracked bed follows along a sinking shore that secrets the drowned town of Allatoona. Phantom seekers claim to hear the ghost train and see specter soldiers on board. Walking through the pass today, you often hear the ghostly sounds of the trains on the repositioned tracks and wonder if they might be from another time or a current train in the distance.

The pass and the lost town of Allatoona have every reason to be haunted. The Battle of Allatoona Pass—a forgotten battle won by fake news and in defense of some bread—destroyed the trackside town. This pointless battle made a few heroes but ruined a town that was later drowned and lost forever.

Residual energy disturbs the pass and the shores of Lake Allatoona, but the scariest story began and ended on October 5, 1864.

Allatoona, Georgia, before the Civil War and before the land was reclaimed for Allatoona Dam. *Courtesy of the National Archives.*

Allatoona Pass tracks and Allatoona. Most of Allatoona is under Lake Allatoona. *Courtesy of the National Archives.*

Allatoona was a farming community littered with several farming plantations according to Brenda Landers Conine, who grew up in the area before there was a lake. She said that Allatoona was a transportation crossroads and W&A stop on the main road toward Atlanta before and after the Civil War. The town established along Allatoona Creek at the southern end of the Appalachian Mountains was part of the Georgia gold rush, and local lore says a silver mine was nearby. The lost town is known for a one-day skirmish in October: The Battle of Allatoona Pass.

Before the battle, Allatoona were bustling. John Clayton was one of the earliest settlers, and he became wealthy in land and slaves. The area had dry goods stores, blacksmiths, a depot and a post office, all on the east side of Allatoona Creek. The Allatoona post office existed from 1838 to 1918. The Clayton-Mooney home, built around 1836, is the lone survivor of the town now drowned. The house has battle scars. Bullet holes and bloodstains that are still visible remind us of the home's use as Union headquarters and a hospital during the battle. Soldiers buried in the yard rest from a micro-battle that is forgotten history in the big picture of the Civil War.[41]

The Battle of Allatoona Pass, Filled with Fake News

In a Macon speech, Jefferson Davis bragged that they had the Union in its tracks. William Tecumseh Sherman got the message and reinforced Allatoona with troops from Rome.[42] Sherman knew the area and prepared to return to the rugged Allatoona Pass, which he used as a Union base to store provisions for his troops as they made their way through Georgia. It was a memorable place with unique geography and an important rail line.

Allatoona Pass is a deep cut constructed by the Western and Atlantic Railroad in the 1840s. The cut was a remarkable engineering feat in the early nineteenth century. The pass was 60 feet wide, 175 feet deep and 360 feet long.[43]

In May 1864, during the Atlanta campaign, Confederate general Joseph E. Johnston established a defensive position around the pass and waited for Sherman to attack. Knowing a direct assault would be difficult, Sherman instead performed a series of flanking movements, forcing Johnston to evacuate the pass which the Federals quickly occupied.

A defense force was placed in the Allatoona community, which author David Evans described as "a wretched and forlorn-looking town of four or five houses scattered around the south end of the railroad cut through Allatoona Mountain."[44] On June 6, 1864, Sherman ordered Allatoona fortified and prepared as a secondary base. According to the *Warfare History Network*:

> By July 14, Union engineers had fortified both sides of the railroad cut, building a four-sided earthen fort encircled by a deep ditch east of the railroad, and a larger, six-sided redoubt on the western ridge. Each fort mounted a smoothbore Napoleon gun and two 3-inch rifled cannon, and was surrounded by trenches and rifle pits; the forest had been leveled for 200 to 300 yards west of the trenches, forming a barrier of fallen trees. The slope on both sides of the cut had also been cleared, giving both forts a good field of fire.[45]

With Allatoona secured, Sherman stored one million pounds of hardtack and salt pork in a warehouse near the railroad. The nine thousand head of cattle in the fields around the village were not lost on the general, who said, "I regard Allatoona of the first importance in our future plans. It is a second Chattanooga."[46] Sherman was anxious to protect it, and when he heard Hood's army was headed for Allatoona,

he decided to move. Sherman sent a signal flag message from Kennesaw Mountain to Allatoona and from there by telegraph to General Corse in Rome, Georgia: "General Sherman directs you to move forward with your entire command to Allatoona"[47]

Union general John Corse was an ostentatious twenty-nine-year-old ex–West Pointer. He got Sherman's message to move to Allatoona and left Kingston, Georgia, but his cars were derailed. The train did not arrive in Rome until seven o'clock in the evening. Corse was in a hurry, and he loaded 1,054 soldiers and 165,000 rounds of ammunition. At 8:30 p.m., the train left Rome for Allatoona. This would double the size of the Union forces at Allatoona. As Corse assumed command from Colonel John Tourtellotte, a message was sent to Sherman. Now standing beside the signalman at the top of Kennesaw Mountain, Sherman made out the message "Corse is here," then remarked, "He will hold it; I know the man."[48] They were still outnumbered.

Confederate general Samuel French was not aware of the Union reinforcements on their way from Rome. French knew the area, however, and procured eighteen-year-old Tom Moore, a local Confederate, to guide him from Acworth to Allatoona. French had learned from two girls about the Union fortifications and the blockhouse filled with rations and eighty Union soldiers.[49]

The railroad and the forts built on both sides of the pass were captured by Union soldiers on June 1, 1864. Between June and October 5, the forts were reinforced, and a wooden bridge was positioned between the eastern and western sides of the pass. This bridge played an important part during the battle. According to Our Georgia History, "An outer position was added, about 100 feet from the eastern fort and the fort itself was modified into the shape of a star so that troops within the fort could support each other during an assault."[50] On either side of the railroad cut, the Union army established two positions on high ground. Troops built a rope and wood slate bridge to connect the two positions. Below the bridge was the deep Allatoona Pass through which the trains rushed. The Signal Corps constructed a platform, and a Union soldier sketched a field drawing depicting the signal tree with flags and telescopes. This signal station was a source of fake news for the confused Confederates.

On October 5, 1864, the Confederates approached Allatoona Pass at 3:00 a.m., the witching hour. The October day dawned with Confederate cannon shelling the outnumbered Union forces 2,000 to 1,944. The Seventh Illinois Infantry Regiment, however, was equipped with new sixteen-shot Henry

repeating rifles. These weapons, the predecessors of the famous Winchester rifles, were used to defend the store of bread rations for the Union army. The rations were unknown to the Confederates.[51]

The battle became fierce, resulting in hand-to-hand combat. Bayonets, swords, knives, rocks and muskets were used to club opponents. Confusion ensued. The Confederates thought Sherman was coming from Kennesaw with reinforcements to overpower them. Sherman was, in fact, not coming. The Rebels accepted the fake news and defeated themselves in battle.

The Confederate forces were under the command of Major General Samuel French and Brigadier Generals Claudius Sears, Francis M. Cockrell and William H. Young. The Union forces were commanded by Brigadier General John M. Corse and Colonel John E. Tourtellotte. Early in the battle, General Samuel French advanced toward the Union position at 8:30 a.m. with a truce flag and demanded General Corse surrender on the western fort. The adjutant waited for Corse's response, but there was no answer. General French sent this note to General Corse:

> *Sir, I have placed the forces under my command in such positions that you are now surrounded, and, to avoid a needless effusion of blood, I call upon you to surrender your forces at once and unconditionally. Five minutes will be allowed you to decide. Should you accede to this, you will be treated in the most honorable manner as prisoners of war.*

"General French must either be a fool, or else he thinks somebody else is one," Corse said. Taking a notebook out of his pocket, Corse wrote: "Your communication I acknowledge receipt of, and would respectfully reply that we are prepared for the needless effusion of blood whenever it is agreeable to you." Tearing the reply out of his notebook, Corse handed it to an aide. "They will be upon us now," he informed Colonel Tourtellotte.

During this truce, the Confederates repositioned for an assault. This move was against rules of warfare.

At 10:30 a.m., the assault began again.

The fight was dirty and resulted in fierce hand-to-hand combat. Confederate forces attacked the fortified Star Fort four times in two-and-a-half hours. During these attacks, a brave private kept the Star Fort supplied with ammunition by crossing the wooden bridge suspended between the pass. Corse was injured at 1:00 p.m., and the final assault occurred at 1:30 p.m.

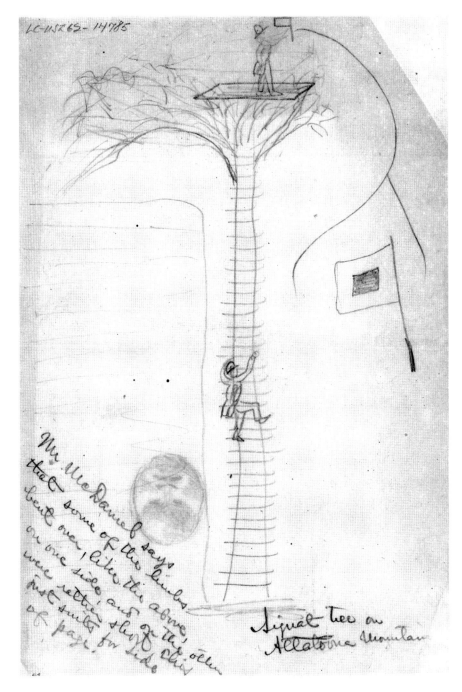

Captain Hubert Dilger's drawing of a signal tree on Allatoona Mountain. The handwritten note explains how the limbs bent over. *Library of Congress, LC-USZ62-14785.*

French was certain Sherman was coming because of the intercepted signal message that said "Hold the fort, we are coming." The message was not true. French retreated with a thousand fewer soldiers, no rations and no victory. His men were angry; they wanted to stay and fight. They did attack the blockhouse with the rations on Allatoona Creek on their retreat. They set the structure on fire and captured four officers and eighty-five Union soldiers. But fearing the Union army, French left the job unfinished.

By 3:00 p.m. it was done, and the retreat was well underway.

The wounded were abandoned, and the Confederates retreated toward New Hope Church in Paulding County. The dead and injured on both sides were everywhere among trenches, ravines, trees and gulches. Dead were found for weeks and buried where they lay.

This battle ranks among the bloodiest when compared to the length of the battle's approximate six to eight hours and casualties incurred.

Real Communication

Not only did the Confederates not get General Corse's message about surrender, but other miscommunications also occurred that day. General Sherman never actually made the statement "Hold the fort for I am coming," as popularized in a hymn by that name. Here is the official communication record from that day:

ALLATOONA, GA., October 5, 1864, at 10:35

General SHERMAN:
Corse is here.

TOURTELLOTTE,
Lieutenant-Colonel, Commanding.

During the battle:

We still hold out. General Corse is wounded.
ADAMS,
Signal Officer.

After French began to withdraw:

We are all right so far. General Corse is wounded.
Where is General Sherman?
 ADAMS,
 Signal Officer.

KENESAW MOUNTAIN, October 5, 1864.

COMMANDING OFFICER,
Allatoona: Near you.

Note: At this point, an unsigned message, stating, "Tell Allatoona hold on. General Sherman is working for you," was sent.[52]

After the battle, the following communication occurred:

Chief Signal officer to Lt. Fish at Kennesaw Mountain: "Ask Allatoona for news." Fish to Allatoona: "How is Corse? What news?" Allatoona [Corse]: "I am short a cheekbone and an ear, but I am able to whip all…"

Today, the *New York Times* is accused of publishing fake news. But on April 26, 1896, it recounted the Battle of Allatoona Pass with clarity and called John Corse the "Hero of Allatoona." (Content was edited for readability—apparently, spelling was not an issue for the *New York Times* in 1896.)

Corse led the Battle of Allatoona Pass for the Union Army. They were outnumbered by the Confederates. He had to save Sherman's rations. He struggled to save the little railroad station at Allatoona Pass or Allatoona Station on Oct 5, 1864, that held the rations for the Union army. Sherman felt his supply was in danger of being destroyed so the Union sent 894 men to protect a million rations of bread. Then General Corse came from Rome, GA in twenty cars loaded with Col Rowett's brigade and part of the Twelfth Illinois Infantry. He left Rome at 8 PM and arrived in Allatoona, thirty-five miles away, by 1 AM.[53]

Interesting contemporary records include a Union private's diary and a sketch by an officer as they were crossing the Chattahoochee River and

heading to Allatoona to protect the emergency rations. A hungry soldier would consider emergency rations and storehouses of bread rations an important thing to discuss in his journal.

"A solder on a march is not expected to carry more than three days' provisions, unless in a county where he is expected to forage." He described marching north to beat General Hood, crossing the Chattahoochee River and hurrying toward Allatoona: "Our most important depot of supplies, where Gen Corse was in command."[54]

The soldier joked about the burned areas around Big Shanty and Acworth:

> *It was the most barren country imaginable, as everything had been burned that could be. Parts of broken wagons still protruded from former mud holes and scattered in every direction were bleaching bones of horses and cattle. Chimneys marked where formerly stood mansions until it became a standing remark: "Another house going up here, got the chimneys built." These Southern people are odd, build the chimney first.*[55]

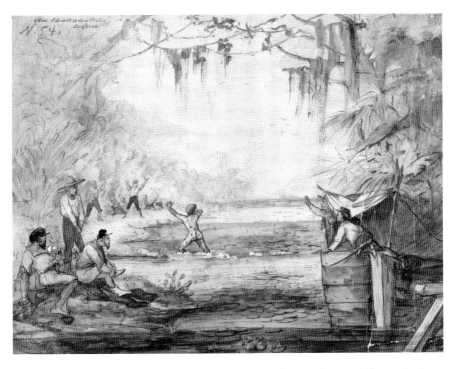

"Bathing in Chattahouchee [*sic*] River, Georgia, with difficulty, July 1864." Captain Hubert Dilger's drawing shows soldiers emerging from a bath in the Chattahoochee River covered in leeches. *Library of Congress, LC-DIG-ppmsca-51276.*

Sherman gained a distant view of the closing military operations at Allatoona. General Corse telegraphed Sherman, "I am minus one ear, part of my jaw, but can whip all hell."

When Sherman saw Corse later, he removed the bandage on his general's face, revealing a flesh wound. Sherman mocked, "General you nearly were not hit by the enemy."

Allatoona Never Recovered

Making a final attempt to drive Union forces from Georgia following the Battle of Atlanta, General Hood ordered troops to Allatoona to fill the deep cut and destroy the railroad lines, preventing Union forces under General Sherman from continuing his March to the Sea. In the words of Allatoona resident Diane Mooney, "The morning of October 5, 1864, proved to be a defeat for the tattered and worn Confederates trying to complete the task. Blood, tears, broken homes, death, but also pride remains saturated in the red clay of the Georgia foothills at Allatoona."[56]

After the smoke had settled and years marched on, Allatoona continued to progress. J.L. Armstrong, a builder of several homes and stores in the Acworth area, settled his family in a lovely Victorian home he built in 1894. He also ran Armstrong General Store. His competition, William McMichen, had a store just across the road. McMichen was raising his family in the old Clayton House. Interestingly, John Clayton had a nephew who rode with Doc Holliday's outlaw gang. It is said that the nephew hid out a while at the Clayton House. McMichen had a grandson named Clayton who became a world-famous fiddler and played with the Skillet-Lickers and the Georgia Wildcats. He later had a star placed in his honor on Nashville's Walk of Fame.

A quaint, primitive-style Universalist church was built in Allatoona around 1910. Several of the founders are buried there in the cemetery. It was also used as a schoolhouse until the WPA built a new school a half mile south and east of the railroad. Growth soon demanded more schools in nearby Emerson and Acworth.

Allatoona Creek became a lake in the 1940s–50s, and this also spurred the construction of Allatoona Landing and Marina. Subsequent additions such as a beach, campground and cabins have taken place. Luckily, the lake construction did not harm or destroy the deep cut and the fortifications still standing from the Civil War battle. Through joint efforts of the Etowah Valley Historical Society and the USACE in the 1990s, preservation of the

battlefield was accomplished. Presently, the park is managed and maintained by Red Top Mountain State Park.[57]

The railroad tracks were moved to the present location west of Allatoona alongside US Highway 41 in preparation for the lake construction in 1950.

Insignificant Allatoona

Just six weeks after the battle, a few miles west of Allatoona, Sherman began his March to the Sea. He schooled Georgia on modern warfare, including the civilian populace. The first step in this great march would be the destruction of the train tracks between Dalton and Marietta, including the track in Allatoona Pass.

Allatoona was important because it supported the Union on this march. The soldiers needed the rations stored there to survive the march. The Union should have lost the battle, as they were fewer in number, but they outsmarted the Confederates. The Rebels thought more soldiers were coming, and they lost the mind game.

Maybe that is why residual energy remains in Allatoona Pass. A one-day battle left two thousand souls on that field on a crisp October day. Maybe these phantom soldiers wonder what so many other supporters of lost causes wonder—what was the point? What was the point?

Original Residents of Allatoona Lake Area

Long before Cooper came to the Etowah River, the Civil War and the Abernathys formed their family town, there was life in the area now called Lake Allatoona. A 1984 geologic and archaeological study found "that the area has been witness to a long and eventful human occupation." The report also suggested that more work is required to fill in the holes in the region's history.[58] In the early 1800s, Cherokees were the main inhabitants along the Etowah River in North Georgia.

Maps prepared for the 1832 land lottery left us with documentation to help reconstruct the Cherokee lands in North Georgia. The state surveyors submitted information about the rivers, streams, land quality and how the Indians improved the land. Attitudes shifted toward the Cherokees between the eighteenth and nineteenth centuries. In these years, everything changed between whites and Native Americans.

Indian traders were the key players in the acculturation process. Traders had not set out to civilize the Native Americans, but the natives adopted European ways. The Cherokees ran their sovereign nation in present-day Gordon County at New Echota. Though this is not directly in the Lake Allatoona area, Cherokees were present and were knowledgeable about agriculture and other modernizations.[59]

Cherokee Indian agent Jonathan Meigs piloted a census in 1809. Another survey was taken fifteen years later and revealed drastic changes in the population. Few whites were in Cherokee territory in 1809, slightly less than 3 percent. Interestingly, slaves accounted for 5 percent of the population. The Cherokee Nation census of 1824 shows the slave population increased from 583 to 1,277, but the white population declined. Between 1809 and 1824, the white population went from 314 to 215 in the Cherokee territory of North Georgia.

The Cherokee industry and population continued to grow. In 1809, there were 13 gristmills, but fifteen years later, there were 36 mills. That 117 percent increase pales in comparison to the increase of 333 percent for sawmills. Spinning wheels and looms were counted, and the increase was over 50 percent. Wagons were 30 in number in 1809 but 173 in 1824, a 473 percent increase. In the 1809 census, blacksmith shops, stores, tan yards, a powder mill and a threshing machine were not counted or didn't exist.

Education was important to the Cherokees. They developed their own alphabet and published a newspaper in their language. The children were not abandoned as schools increased from five to eighteen in this changing time and the number of students enrolled from 94 to 314. The 243 percent increase in educated students demonstrates how the Cherokees valued teaching their children.[60] The Cherokees were so successful at emulating Europeans, it may have led to their downfall.

In 1827, the Cherokees declared themselves a sovereign nation exempt from the laws of Georgia and the United States. In the same year, the Georgia legislature exerted power over the Cherokee lands. The area was annexed to a few North Georgia counties. White populations came. They came for gold.[61]

Although many people came to mine gold in Lumpkin County, beginning in the lost town of Auraria, most were not permanent settlers.[62] Many moved on to Alabama, Colorado and California. The 1832 gold lottery, however, created white settlements. In 1831, Georgia's government knew the Indians would be removed and surveyed more than 6,800 square miles and divided the land into four sections. Land districts were laid off

in 9-square-mile sections and then divided further into forty-acre gold lots. The gold lots were designated as such because the land might contain gold. Other areas were laid off into 150-acre land lots. A public lottery distributed the sixty land lots and thirty-tree gold districts. Whites poured in to claim the land. Some Indians left before they were evicted. Some patient land owners waited until the final removal of the Cherokees in 1838–39.[63]

The new Georgians renovated their farms to suit them, and white settlements were formed. Settlements are essential for permanence. According to Gregory Jeane, "It is the local group which supports the individual and the family through rough times and that is responsible for 'passing along' the culture to subsequent generations." The communities around the Lake Allatoona area were growing and vital. They remained important until recent times.[64]

The Corbin community, the Fields settlement and the Macedonia community are still remembered by locals. Families and kin settled together like the Abernathys in Abernathyville. The families started local churches; thus, a community usually had a church and a cemetery. The moving of these churches and cemeteries required delicate negotiations by the USACE. The settlements created a complex web of trails, lanes and roads. Some roads were former Indian trails. The landscape around Lake Allatoona is often a strange conglomeration of dead ends and confusing dirt roads.[65]

Sixes Old Town

Hidden below the surface of Lake Allatoona is the lost town of Sixes, an early, maybe the earliest Cherokee village in the Cherokee Nation, formed around 1799. Located near the intersection of the Etowah and the Little River, Sixes Old Town lies in the middle of the lake. According to Goff's *Placenames of Georgia*, the area also was called Sixes Old Town, Sixes District, Sixes Creek, Sixes Mine, Sixes Trail and Sutallee. Today, you can drive toward Cherokee County on Highway 20 and see the community of Sutallee. This was part of the Sixes community. *Sixes* is the English perversion of Sutallee (Sutalli), and no one is sure what it means. Some say the area was named for the six gold mines that have long since played out.

The Georgia Militia District No. 1279 in southwest Cherokee county is where Sixes Creek turned into the old Sixes Gold Mine. Six miles southwest

of Canton, a mine began producing gold in 1831. In 1849, while so many rushed to California, Sixes mines produced $200,000.[66]

Before the waters flowed to form Allatoona Lake, Sixes was a town of open fields and the plantation of Joseph E. Brown. Before that, four hundred Native Americans lived in the settlement. In 1833, the town had a chief named Stop. The confusion about the name's origin deepened when Goff suggested that the word Sixes might refer to a designation of an important person like a chief. Another explanation in *Placenames of Georgia* asserts that "Cherokees used numerals with a noun suffix title *tehe*, or *tehee*, signifying killer, to indicate various graduations in rank."[67] So, *Six Killer*, another name for Sixes, was an important name with war implications. Also, the name might have been a mythological designation. The significance of the name cannot be proven and may be lost to history. Either way, Sixes is buried under the Cherokee county portion of Lake Allatoona.

Victoria's Secret

Victoria Harbour Marina on the Cherokee County side of Lake Allatoona has the best sunsets, according to the local lake enthusiasts. Along those banks, several boaters on Lake Allatoona have reported ghostly images on their boats' sonar of an old iron bridge. These fish finder images foster speculation that there was a bridge sunk in Lake Allatoona, but there is no evidence. It's a mystery. Lake Lanier has several bridges and roads that were submerged, but they are recorded. After searching, the only evidence of a bridge goes back to the 1800s in a place called Victoria's Landing.

Victoria was a community a mile from the marina. It was on the former Lovingood Road that went to Lovingood's Bridge and crossed the Etowah River. Lovingood Road was renamed Victoria Landing Drive. A town grew up around the crossroads and a store. The owner of the store, a Mr. Robinson, named the town after his wife, Victoria.

Lovingood's Bridge was one of the few bridges that crossed the Etowah during the Civil War. Both sides used it to cross, and Sherman used it in his March to the Sea. It was mentioned in official dispatches and soldier diaries during the conflict.

The Etowah River is the main river that forms Lake Allatoona. Lovingood's Bridge spanned the river almost straight out from the restaurant at the marina.

In 1854, Samuel Lovingood Jr. was a large landowner and businessman in the area around the Etowah River. He opened a bridge to service his mill and made money from tolls. No one is sure if the bridge was burned during the war or washed by floodwaters later, but when the bridge was gone, Lovingood ran a ferry. The area was known then as Lovingood's Landing and later renamed Victoria's Landing.[68]

Nothing remains of the store or the town, but the name Victoria remains. The question is, what is the bridge Allatoona boaters are spotting? Could it be a rebuilt version from Lovingood or Victoria's Landing? Maybe it is just the beginnings of a good untold story.

FARMING IS OVER

Taking a significant leap from the early 1830s, farming in the Lake Allatoona environ was over by the mid-1920s.[69] The farms around the Allatoona Lake area were small and focused on subsistence crops such as corn. Cotton was for cash. The rich bottomlands near the Etowah River grew corn, and the steep slopes grew cotton. Production slowed as the land was depleted.

In 1957, the *Atlanta Constitution* ran a column by Calvin Cox titled "Farmers Migrating En Masse to Cities." It stated, "Missing: 60,374 farms, last seen in State of GA. Description: Rather small, some with deep furrows across the face; many dressed in non-descript, one-crop clothing, worn and tattered. Disappeared during years 1950 to 1955."[70] Cox pointed out that in 1920, there were 310,732 farms in Georgia, and by 1957, only 165,532 farms remained. The columnist blames many missing farm acres on the reservoirs that sprang up in the 1950s. He lamented, "Fish swim where the cotton bloomed and corn tassel waved in the gentle breezes....Allatoona Lake put its wet hand across the land and Lake Lanier today is stretching out its fingers. There are others. Land changes and the people change....[T]he small units fall apart whether they be farms or people."[71]

DRAMATIC CHANGE IN THE ETOWAH VALLEY

Beloved *Atlanta Constitution* columnist Celestine Sibley wrote an article in 1949 marking the dramatic change in the Etowah Valley: "History-minded

Georgians and visiting historians from other States are preparing today for a final pilgrimage to a soon-to-be-submerged land where some of the lustiest, liveliest dramas of the past were played out."[72] Sibley reported that the Kennesaw Mountain Historical Association had a full day of events, including touring the landmarks that would soon be flooded by the USACE when it closed the gates on Allatoona Dam in December 1949. Tours included Mark Anthony Cooper's ironworks and the foundations of his old home, Glen Holly. She wrote that the graves of the Cooper family would soon be "lifted to new resting places."[73]

Sibley remembered the Battle of Allatoona Pass. She said it was a bad day for the Confederates. They never could fill in the gap, and when they went to burn down Sherman's supply house filled with food and ammunition for his march through Georgia, they failed. The two Confederates sent to burn it down found "they only had two matches between them and those would not light."[74]

Today, Allatoona Pass is an eerie souvenir of a forgotten battle. The only remaining structure is the Mooney house, which served as a hospital that day. Its walls are scarred with embedded Minié balls, and its floors retain spilt blood. The property has unmarked graves dotting the backyard. An unknown soldier is buried down the road. Little remains of Allatoona. The pass and the Mooney house sit on the banks of Allatoona Lake, quiet and solemn. The ghosts have settled into the blood-soaked soil and are now resting in peace.

ALLATOONA SAVES ANOTHER TOWN FROM BEING DROWNED

With the flooding of Etowah, Allatoona and Abernathyville, another town was saved. The Flood Control Acts of 1941 and 1945 authorized the USACE to begin the dam that was proposed in the 1930s. Though approved in 1941, the real work did not begin until after World War II in 1945. Lake Allatoona had seven authorized purposes: hydropower generation, water supply, recreation, fish and wildlife management, water quality, navigation and flood control.

Floods in Floyd County had to stop. A record flood on April 1, 1886, drowned Rome in 40.29 feet of water. This was 15.29 feet above flood stage.[75] The swollen river turned Rome's wide Broad Street into a canal. During the

flood, a steamboat made its way up Broad Street until Third Avenue.[76] The water damaged the progressive Rome by destroying the stores, farms, crops, the new electric lighting, streetcar and electric light.

B.I. Hughes, a cashier of the First National Bank, said that "the water [rushed] over the doors of the vault and perhaps $100,000 in bills flooded. He took out the packages, heavily covered with river mud, and spread the bills before a great fire, and in time had them all dry. The bank did not lose a dollar except a small lot of new stationery."[77] Rome would flood again. After the flood in 1886 and 1892, the city decided Broad Street had to be lifted. Several buildings were raised eight to nine feet. Evidence of the raising remains in the basements of some businesses, and tours give evidence of a different era.

Even with the uplifting of Rome's main street, the flooding needed to end. Atlanta needed power and water, and the wild Etowah would be tamed by the placement of Allatoona Dam, stopping the flow and creating the reservoir as a resource for all of Georgia.

3

J. Strom Thurmond Lake

1953

A town which has risen out of the woods in a few years, as if by enchantment.
—George Sibbald

Petersburg

Petersburg was dead long before 141 feet of lake water buried it. Drought at J. Strom Thurmond Lake exposed red bricks and rusty pieces of relics of a rich history. Situated for success, Petersburg prospered in the late eighteenth century until commerce changed. From the 1780s to the 1820s, this thriving township had a purposeful beginning. But then things got complicated.

Petersburg was a planned community. Over two centuries ago, Petersburg was Georgia's third-largest city. The town had paved streets, several schools, a newspaper and a prosperous population. Petersburg boasted of producing six governors and two U.S. senators.

Petersburg's prosperity was all about location and the money crop of the day: tobacco. The problem was that the town was born for tobacco and died for tobacco. When the markets changed, Petersburg became a pauper town. Transportation changed, and people went west. The community died a slow, insignificant death. Before the 1850s, it was finished. About one hundred years later, the area is almost entirely covered by a lake.

Petersburg's Plan

A young Georgia wanted and needed immigrants. George Sibbald wanted people to immigrate and settle the wild Georgia landscape. So, in 1801, he wrote a travel brochure enticing people to move to Georgia. Sibbald sang the praises of the young town of Petersburg:

> *Petersburg, in point of situation and commercial consequence is second only to Augusta. It is situated on the point of land, formed by Broad River, where it empties into Savannah River; is a handsome well-built town and presents to the view of the astonished traveler, a town which has risen out of the woods in a few years, as if by enchantment: It has two warehouses for the inspection of tobacco: Is fifty miles Northwest from Augusta. On another point of land on the opposite side of Broad River is the town of Lisbon, which has an Inspection for Tobacco, some Stores, &c. On the opposite shore in South Carolina, is the town of Vienna, which has a number of houses, stores, a tobacco-inspection.*[78]

Longstreet described the town between 1806 and 1809 in connection with an annual exhibition at Moses Waddel's nearby Willington Academy:

> *Petersburg was quite an active, busy, commercial little town. It was situated in the fork of the Savannah and Broad Rivers and contained some eight or ten stores, with the usual supplement of grog shops, and the very unusual supplement of a billiard-table. Notwithstanding these last, the citizens of the place were remarkable for their refinement, respectability, intelligence, and hospitality. The dwelling houses far outnumbered the stores and shops. It was separated from Lisbon by Broad River, and from Vienna by the Savannah. Lisbon we believe could never boast of more than two stores and a groggery, and as many dwellings. Vienna surpassed Lisbon in everything, but exactly how far, and in what we are not able to say, except in John Glover's house and store, which had no match in Lisbon.*[79]

Before there was a town, the Broad and Savannah Rivers met to form a perfect place for a community to settle and grow. According to Rita Elliot in her thesis, "The Pulse of Petersburg: A Multidisciplinary Investigation of a Submerged Tobacco Town in Georgia," "Before the town's founding, this area provided an environment conducive to trade. The Broad and Savannah

Where Petersburg is located. *Courtesy of Rita Elliot, "The Pulse of Petersburg."*

Rivers provided Indians and Englishmen with an easily accessible route for trading goods."[80]

Early traders took advantage of the river highways to intrude on Indian lands. Early settlers needed protection, and by 1775, Fort James was built where the rivers meet. Famed botanist William Bartram described Fort James—a square stockade and block house with swivel guns—when he

traveled through the area in 1776: "The fort stands on an eminence in the forks between the Savanna and Broad rivers, about one mile above Fort Charlotte, situated near the banks of the Savanna, on the Carolina side. Fort James is situated nearly at an equal distance from the banks of the two rivers, and from the extreme point of the land that separates them."[81]

James Wright, a royal governor of Georgia, saw a future for this area. He wanted to develop it. To gain favor with British aristocracy, Wright called the area Dartmouth in honor of the Earl of Dartmouth; the Broad River was renamed Dart. Before the English could develop this part of Georgia, the Revolutionary War intervened, and the names did not stick.

Before the war, the land belonged to the Creeks and the Cherokees, but Wright and John Stuart, superintendent of Indian affairs, convinced them to pay their trading debts by surrendering the area between the Broad and Savannah Rivers. With the North Georgia doors wide open, enter Dionysius Oliver.

Oliver received land as a Revolutionary War veteran from the state for his wartime participation. One of the grants included the area between the forks of the Savannah and Broad Rivers. Oliver, a Virginian, grabbed three hundred acres from the Georgia General Assembly in a land grant on January 12, 1784. This ground belonged to the Cherokees and Creeks in 1773. Oliver settled at the fork of the Broad and Savannah Rivers. Then in 1786, the Georgia legislature authorized Oliver to open a tobacco-inspection station and warehouse in Petersburg. Originally in Wilkes County, the lines were redrawn, placing Petersburg in the new county of Elbert.[82]

A rough draft of Oliver's Petersburg plan shows how he divided the land into eighty "one half acre forty-four yards and fifty-five yards extending outwards." This surviving document lacks scale and direction, showing the Petersburg surveyor's skill deficiencies. According to Elliot, many scratch-outs and mistakes

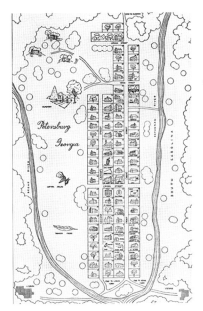

Map of Petersburg in the 1700s from Coulter's book on the lost town of Petersburg. *E. Merton Coulter,* Old Petersburg and the Broad River Valley of Georgia, *1966.*

appear sloppy and suggest possible tampering with the town map. The surveyor's name is scratched out. He was ashamed of his work. Petersburg outgrew this plan to ninety-five lots and more cross streets—Oliver was on to something.[83] By 1808, the original lots had sold.

Petersburg's Prosperity

The years between 1789 and 1809 were a time of prosperity for Petersburg. The government required tobacco inspection, and Petersburg had the perfect location. The river highways and proximity to growers kept the town busy. Georgia was one of the top tobacco producers. King cotton had not yet become the cash crop.

Tobacco pushed land prices up in Petersburg. Records depict fine homes, doctors' offices and a public well. Tobacco warehouses with docks joined the town, and cobblestone streets connected it all. Petersburg boasted over 750 residents; the entire Broad River Valley had 45,000 people living in the area.[84]

Petersburg merchants shipped tobacco in hogsheads, or large barrels with no bulge. Shipping containers hid the product, so inspectors checked it for the buyers. Government inspectors graded and stamped the hogshead lids. Georgia branded its tobacco and required a quality product. Dishonest inspectors could face the death penalty or, at the very least, strict fines. A bad product that made its way to Charleston would force Georgia tobacco prices to drop.[85]

The roads were rough in North Georgia, and shipping products cross-country was arduous. Petersburg with its rivers provided transport where no roads existed. First, farmers brought tobacco into Petersburg for inspection. Next, they sent hogsheads downriver to Augusta in either tobacco flats or the Petersburg boat. These special boats were built to navigate these two big rivers. One boat made the trip to Savannah work.

The Petersburg boats replaced deficient crafts called tobacco flats. Petersburg Boats were built to navigate the shallow waters of the Savannah River. They were seventy-five feet in length, six feet wide and pointed at both ends, with round bottoms.[86] These boats also navigated the rivers between Petersburg and Augusta.

Crews had to work together with skill and strength. The downstream trip was at a four-mile-per-hour pace under peak conditions. Upstream travel was over one mile per hour. A trip to Augusta and back to Petersburg took six or seven days. Obstacles or a careless crew would make the trip longer.

Photochromic of the Savannah River, 1900. *Detroit Publishing Company.*

Many obstacles within the river caused the Georgia legislature to lend aid to enhance the waterway. The Savannah River is on the South Carolina border, and the states disagreed. South Carolina made few attempts to clear the river obstacles. Georgia levied tolls downstream, causing conflict. A lottery didn't raise money, so the government taxed landowners along the river. As they deemed the levy unfair, they refused to pay. Fishermen would not remove traps or help clean the river.[87]

Petersburg's Problem

There was trouble in Petersburg's profitable paradise. The town's short lifespan had tobacco, cotton, war and westward expansion to blame. It had found fortune, but decline was inevitable. The War of 1812 interrupted trade, which was the core of Petersburg's identity. People had moved there to share in prosperity.

Worldly residents created a society with culture and amusements. Theater, dancing and social events brought people to town. The first sign of decline was when society began to fade, and the music stopped playing in the streets.

The miracle town was conceived by tobacco, but it was the leaf that killed Petersburg. The price of tobacco undulated from three and a half cents a pound to four and a half cents until 1811. With the rumors of war with England, prices dropped to about two cents a pound. Farmers stopped growing tobacco and switched to cotton. The European market was drying up due to increased duties and local competition.[88]

Georgians were familiar with cotton. Landowners planted it as an ornamental yard plant. Its fibers were mixed with wool to create filling or padding. Effective machines had not been invented to separate the fiber and the seed. The cotton plant would not be a cash crop until someone figured out how to separate seed from lint.

Early gins (as these cotton machines were called) had rollers that cracked the seed into the lint. According to Coulter, "About the time when gins was uppermost, and excitement was welling up over the possibilities of cotton becoming the miracle crop for the south, Eli Whitney appeared on the scene in 1792."[89]

Coulter continued, "The coming of the cotton gin was the forerunner of storm clouds ahead for Petersburg. The town had been born of tobacco and was cradled in tobacco warehouses supplied by the rich lands of the Broad and Savannah river valleys."[90] The cash contest was called, and cotton would eventually win.

The Passing of Petersburg

Real estate prices were the first sign of the decline of the community. John Williams Walker commented in 1809, "I could hardly give away my lands now, they are in so little request."[91] Property values were so low the Elbert County sheriff sold an acre lot adjoining Petersburg for $36. When prices jumped after the War of 1812, a lot sold for $2,500. A few years later, in 1826, the lot was resold for $275. By the late 1830s, Petersburg was in decline.[92]

The town government was abandoned years before 1831, and the countryside took over the city streets. Postal receipts declined. Augusta was smaller than Petersburg, but in 1827, Petersburg postal receipts were only $105.17 while Augusta's were $10,493.26.[93] Where were these people going? West!

The westward movement to Alabama and Mississippi was so extensive that Georgia newspapers began to publish fake news. Coulter reported in his book *Old Petersburg*, "To prevent the headlong migration to Alabama

and Mississippi, the Georgia newspapers were glad to publish any news of a discouraging nature. There were Indian troubles, floods, and disease."[94] The fever was rising, and many prominent Petersburg residents became Alabamans.

By 1843, three families remained in Petersburg. There was a little excitement when Jefferson Davis and his cabinet ran from Federal troops and crossed the Savannah River below Petersburg. The Confederate government passed out the gold and silver to keep it from the Union army and threw the golden seal of the Confederacy into the river.[95]

Historians, reporters and Petersburg descendants returned in the late 1800s to comment on the remnants. Charles C. Jones, an Augusta historian, wrote, "Now sunken wells and the mounds of fallen chimneys are all that attest the former existence of the town. Its corporate limits are wholly included within the confines of one well-ordered plantation; and extensive fields of corn and cotton have obliterated traces of warehouse, shop, town hall, church, and dwelling." Seven years later, another observer said that old Petersburg was "a wilderness of cotton-wood, broom sedge, and blackberry bushes, with not even a solitary chimney to mark the spot where it stood."[96] Lands that once sold by the foot and streets full of wealthy tradesmen are now silent and sullen, overcome by agriculture. In 1888, an *Atlanta Constitution* journalist recorded his visit to old Petersburg. He noted that it was difficult to record the town's history because people could only remember the decay: "Had the curse of God fallen upon this town, its obliteration from the face of the earth could not have been more complete." He visited the old town graveyard and said, "There is not a sadder sight on earth than a discarded graveyard. The vaults fallen in, the stately marble shafts toppling over, and the monuments and tombstones wrenched as if by some confusion of nature. A dense and mostly impenetrable thicket of vines and all manner of shrubbery that have been allowed to run wild."[97]

The editorialist had a theory: "Fulton's invention of the steamboat sounded its death knell." Transportation changed, and the railroad never came within seventy-five miles of the town. Petersburg was cut off.[98] Once the town's purpose ended, so did the town. Its citizens moved to new towns with a new purpose. Petersburg was never to return.

Petersburg at Peace

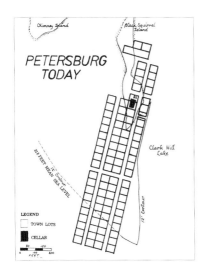

What lies beneath J. Strom Thurmond Lake. The location of old Petersburg. *Courtesy of Rita Elliot, "The Pulse of Petersburg."*

Almost one hundred years later, a team of divers was investigating under the Clarks Hill Reservoir (now known as J. Strom Thurmond Lake). They found bricks scattered and bricks inlaid in a wall. They entered a cold channel under the lake and discovered the Savannah River channel. The researchers mapped the location of the old town, which now resides fifty feet under the lake.[99]

Petersburg surfaced during Georgia's drought conditions. J. Strom Thurmond Lake lowered almost fifteen feet, and people saw pieces of the town for the first time since the completion of Clarks Hill Dam in 1943. "We get a lot of questions, and we have a few people who come all the way out here just to see it," said Jerry Cook, assistant manager at Bobby Brown State Park, which straddles the lake's shoreline in Elbert County. "Most of what you can see is bricks from old foundations."[100] The debris exposed during the drought is different from our trash: rusty spikes, glass shards, bricks, lots of iron and broken pottery.

During low-water times, if you find a piece of the past, better leave it there. Treasure hunting is against federal laws, enforced by the USACE and by state organizations governing historic sites. A Corps biologist remarked, "There's not much here today....But 200 years ago, it must have been quite a place." Once the rains returned and filled the reservoir, the forgotten fragments of old roadbeds, fence lines and foundations from the ghost town of Petersburg were lost.[101]

What Happened to Oliver?

Dionysius Oliver founded Petersburg in 1784 with three hundred acres. In 1808, he died in his beloved town. When the USACE began work on the Clarks Hill Dam, fifty graves were moved, one of them that of Revolutionary

War privateer Oliver. His remains and his new military headstone were moved to Stinchcomb Cemetery near the town he founded in Elbert County, Georgia.[102] The dam and the lake were completed in 1943.[103] The name has changed, but residents are still confused. People and old sources still call the area "Clark Hill Dam and Lake."[104]

New Purpose

A review by the Savannah District engineer was completed in 1939, but World War II stopped the project. While being developed, eleven other multipurpose projects were being considered. The Clarks Hill site was developed for flood control and hydroelectric power, but recreation was a consideration.

To cut costs, the Corps intended to top the trees instead of cutting them. Local residents were worried about boating safety and malaria due to stagnant water around the trees when the water was low. Finally, the local district cleared all the vegetation to prevent problems.

4

LAKE SIDNEY LANIER

1957

I never did like the lake, and I don't like it now.
—Lloyd Cecile Martin

Henry Shadburn was the first. On April 14, 1954, a press conference was staged. The eighty-one-year-old Forsyth County farmer signed over his farm to the government, and with that, Lake Sidney Lanier was more than just a plan, it was becoming a reality. Shadburn was paid $4,100 for one hundred acres near the Young Dear area of Forsyth. In 2018 dollars, he sold his homestead for $36,798.[105] The amount seems miniscule considering a lifetime of working the land and building a home. Many residents were happy with the cash in hand; others fought to stay, but in the end, over seven hundred families were forced out as the water behind Buford Dam rose.

At first, the government assured land owners that they were being paid for the true value of the land and buildings, but residents found it hard to price generations of memories, hard work and deep roots. A host of emotions accompanied the talk of relocation: anger, resentment, fear, anxiety, bewilderment and apprehension.[106] Most felt it was not fair to give up everything. To them, their land was priceless.

By and large, most land owners were happy to get money in their pockets. As subsistence farmers, this may have been the most money they had ever seen. They fed their families with what their farms produced. Cash money was rare. After the press conference, Henry Shadburn—with check in hand—asked his lawyer for ten dollars. He had to pay for deed transfer fees.

A. Shadburn Home (A103 Bldg 1). *Courtesy of Robert D. Coughlin and the U.S. Army Corps of Engineers.*

The negotiating attorney, N.G. McKinley, said it was unusual, but he figured Shadburn was good for it.[107]

Usually, dam projects required quiet acquisition and relocations, but Lanier was very public. The engineers did not have all the answers as they began, and questions flew around the community. The *Gainesville Daily Times* started collecting questions and finding answers. The newspaper ran a Q and A series in 1954. These questions showed uncertainty:

> *"Frequent Dam Puzzlers Listed"*
>
> *Q: Is Atlanta's water supply the main reason for buying the dam?*
> *A: Mayor Bill Hartsfield of Atlanta dispelled this idea at an Atlanta meeting in November 1949 when he said, "Atlanta's water supply is not an issue. It is not water that we need but regulation of water. Although the Chattahoochee river is the most convenient, it is not our only source of water."*
>
> *Q: How do folks who now have reservoirs feel about them?*
> *A: The* Cartersville News-Tribune *in a recent editorial reported that citizens were pleased with the lake. It said, "They'll be public camps and picnic grounds, swimming beach and boating facilities, a lodge, overnight, and vacation cabins, and many other such projects of recreation and sporting."*

Q: What will you do about malaria prevention?
A: We can ditch, spray, several things. We send in special crews. You won't
be any worse off than you are now.
Q: We don't have any mosquitos now.
A: Well, we'll see if you get any, then we'll stop 'em.

Q: What will be done with graveyards?
A: The nearest of kin is notified and asked to name a new site for the grave.
The government moves everything from a cemetery. Unknown graves are
removed by court order. The government will not flood a cemetery.

Time revealed that the success of those relocated was mixed. A few adjusted. Others did not. They could not replace their land with the money they received. Moving from land they had lived off of for generations was a difficult adjustment. Few prospered. They never had much cash in hand. They were subsistence people, people who bartered and lived on what they grew. Handed a great sum, they did not manage it. They were not happy. The first signer, Henry Shadburn, had a bad experience: "It cleaned us out; we hoped to break even. This turned out to be a miscalculation."

J.P. Gaines gave up land that had been in his family since 1911. The 229 acres were located 5 miles west of Flowery Branch. He received $18,020 for his land ($161,732.51 in 2018 dollars). The eighty-year-old farmer decided to move to Flowery Branch. According to the local newspaper, "His face clouds when he thinks of the dam." He said, "I just don't like it. It may be good for some folks, but it's bad for me and my wife."[108] He was not alone in this thinking.

Sitting on his new front steps near Lake Lanier, Shadburn had a chance to settle in and think about his deal with the government. His wife sat rocking on the front porch as they both looked longingly in the direction of Lanier and the property that had been in his family for five generations. Shadburn echoed J.P. Gaines: "I don't like it at all." Mrs. Shadburn sighed, "It'll never feel like home."[109]

The Political Dog and Pony Show

The sunny day in March 1950 belied the heavy rain the day before. Organizers planned the groundbreaking ceremony to the smallest detail. They thought of everything except what rain does to red-clay roads. Two

days of rain had done its worst at the remote construction site of Buford Dam. Dignitaries came to speak and handle a silver shovel to turn over the dirt—or the mud—that symbolically started the unnamed reservoir project on the Chattahoochee River. Unlike any other dam project in Georgia, this was ushered in with pomp and circumstance, even if the pomp was stuck in the inches of red mud.

Plans for this project began in the 1920s but halted during the Great Depression. During the recovery and after World War II, the politicians got involved. As momentum built, the cost of the project grew to $45 million. In order to have influence, Atlanta mayor William B. Hartsfield helped lead the project. He saw the reservoir as flood insurance, but water supply regulation was on his mind. Atlanta, the "New South," was growing. Hartsfield had even considered introducing barge traffic from Columbus to Atlanta.

Consequently, Hartsfield was accused of looking out for Fulton County's water supply. He denied it. Two speakers that day, Governor Talmadge and Hartsfield, promised growth for the state. Hartsfield said the dam and reservoir guaranteed industrial development. Governor Talmadge echoed these thoughts by saying that the South had missed previous industrial revolutions, and the dam project brought hope for economic growth. Other politicians weighed in.

Though he could not attend the groundbreaking ceremony, U.S. senator Richard B. Russell Jr. was a powerful voice for the USACE and the reservoir projects in Georgia. In 1933, when the dam was still under consideration, Russell took office. Russell argued for Buford Dam in the Senate. He was so instrumental that Hartsfield wanted to name the lake after Russell.

THE NAME

Even the naming of the dam and reservoir was a political issue. The U.S. government has the authority to name federal property. The naming of Buford Dam and Lake Sydney Lanier was quite a production. At the beginning of the project in the 1940s, it was called Buford Lake. When the politicians got involved, the suggested names had interesting twists. The lake remained unnamed until the late 1950s.

Mayor William B. Hartsfield wanted to name the lake after Richard B. Russell, the longtime Georgia senator who was a major figure in getting the project approved. Others wanted to name it Hartsfield Lake

after the mayor. Someone suggested Will Rogers, the popular cowboy crooner, because a distant relative lived along the Chattahoochee. Another suggestion was to honor Bobby Dodd, the legendary Georgia Tech football coach. The only problem was that in the 1950s, saying "Dodd Dam" on the radio might be offensive.[110]

The Sons of Confederate Veterans John B. Gordon Camp No. 46 of Atlanta sent a letter to Senator Richard B. Russell suggesting "Lake Sidney Lanier" for the "big body of water that will be formed by the Buford Dam across the Chattahoochee River."[111] The group wrote:

> *While Sidney Lanier has always been honored and loved throughout the South, to the best of our knowledge, this would be the first time that an honor, national in scope would be given to him. To give the name of the poet who wrote the beautiful, "Song of the Chattahoochee," to a lake formed by this river, seems to us to be a fitting memorial to Georgia's Sidney Lanier.[112]*

The only one who fought this name was one of Lanier's descendants. J. Smith Lanier lived in West Point and wanted to have a reservoir closer to home named for his relative. A dam north of West Point had the proposed name of Lanier Dam. This dam was never built.

A federal law had to be created to name the lake. Representative Phil Landrum sponsored the bill to name the reservoir. Between 1954 and 1956, the bill found its way to Vice President Richard Nixon and Sam Rayburn, who signed it. When the bill was finally signed by President Dwight D. Eisenhower, the gates of Buford Dam had been closed on the Chattahoochee for three months. The poet for whom this lake was named might not recognize this new body of water, as the river filled thirty-eight thousand acres. The filling was to take one year, but it took two.[113]

The Filling

On February 1, 1956, the gates of Buford Dam were closed. Much like the groundbreaking, the closing was a ceremonial event. The switch was flipped by several dignitaries, and after the gates closed, a bucket of water was symbolically drawn. It was handed to Paul Weir, the Atlanta Waterworks manager, as a gesture noting the beginning of a new era—the regulation of the Chattahoochee River.[114]

On the river side of Buford Dam. *Author's collection.*

Buford Dam trail race. *Author's collection.*

As the lake filled, local residents could not resist watching it rise. They gathered on old bridges before they were covered with water. They watched lost items float around the reservoir and some get caught by the dam gates. Traffic jams formed on narrow roads when gawkers stared at things soon to be out of sight—lost to the waters. Local history was disappearing before their eyes.[115]

LOOPER'S TRACK

In 2008, Georgia was experiencing a severe drought. The lakes of North Georgia dropped to their lowest levels since impoundment. Lanier had interesting artifacts surface. Lost roads, not seen in fifty years, resurfaced. The usual tires and boat parts were cemented in the red mud, but an eerie grandstand rose from the water.

Looper's racetrack, or Gainesville Speedway, was created out of Max Looper's cornfield in 1947. For ten years, the half-mile dirt track sat beside the Chattahoochee River, providing entertainment for Forsyth and Hall Counties. According to ESPN.com, "The track was a playground for the first generation of NASCAR drivers—regular men with regular jobs and

Looper Building. *Courtesy of Robert D. Coughlin and the U.S. Army Corps of Engineers.*

Left: Looper Grandstand. *Courtesy of Robert D. Coughlin and the U.S. Army Corps of Engineers.*

Right: Looper Grandstand revealed during the Georgia drought, 2009. *From the* Gainesville Times.

irregularly fast cars who often trafficked moonshine into the mountains."[116] Then the lake closed the tracks. During the drought, the cinder block grandstand appeared again.

VANN'S TAVERN

One historic loss to the area was Vann's Tavern. In 1956, Vann's Tavern was disassembled at the Lake Lanier site and rebuilt in the New Echota State site. The Cherokee Nation's memorial in Gordon County was under development. The cabin, built in 1805 by Cherokee James Vann, became the first building in the extinct Cherokee village.

The tavern was built in soon-to-be-flooded Oscarville. Each piece was marked and plans written to make the reconstruction easier in New Echota. As Vann's Tavern was being put back together, a time capsule was embedded between the stones of the fireplace and covered with mortar.

Inside the cylinder was a cover from Dr. Henry Malone's book *Cherokees of the Old South*. The New Echota issue of *Early Georgia* was included with a joint issue of the *Gordon County News* and the *Calhoun Times* containing a story and a picture of the tavern. Also, three 1956 pennies were tossed in along with a 1955 silver dollar. Finally, a document, written in both Latin and English, was included in the time capsule:

> *This building, known as Vann's Tavern, was originally erected about 1805 by the Cherokee Indian Chief James Vann, on the Federal road*

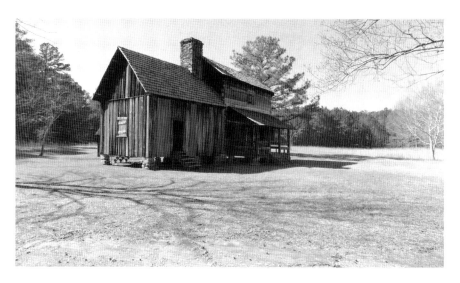

New Echota, after 1956. Vann's Tavern was built around 1805 by James Vann, a Cherokee Indian. *Author's collection.*

near Oscarville thirteen miles west of Gainesville, Georgia, overlooking the Chattahoochee River. It was saved from the flood water of Lake Lanier, and moved to New Echota, once the capital of the Cherokee Nation, where it was re-erected on this spot, the site of a former tavern, by the Georgia Historical Commission during the second year of the administration of his excellency, Governor Marvin Griffin of Georgia. Annon Domini 1956.[117]

THE GHOSTS OF LAKE LANIER

The Cover Up

The subplot to the story of Lake Lanier is the lost community life. Ghost towns, above ground or drowned, are symptoms of what lies just below the surface. The New South sacrificed its culture in a desperate need for power and control. The reservoir and the dam era are micro-histories of North Georgia. This slice of time changed everything. The process of change is a sad process. It is no wonder that with all the attention on Lanier, ghost stories grew out of the unsettled atmosphere.

There are stories of catfish as big as a Volkswagens under the water near a bridge. The tale goes that a chicken truck dumped its load into the lake,

and the catfish grew fat. Divers have sworn to seeing these monstrous fish. YouTube abounds with divers' videos of sunken house boats and strange treasures of no value. Tales may have a grain of truth, but over six hundred deaths on the lake since 1956 are hard to ignore.

The *Atlanta Journal Constitution* reported in May 2017 that since 1994, at least 160 people have died on the lake. In 2016 alone, Lake Lanier saw 17 deaths. DNR spokesman Mark McKinnon said, "There are simply more incidents on Lanier due to the volume of visitors." McKinnon asserts that Lanier has more visitors than any other lake in Georgia.[118] But logic goes out the window when you learn that some bodies were never recovered.

In a CBS46 Atlanta Halloween story, "Is Lake Lanier Haunted?," Nicholas Baggett of the USACE said there's been "hundreds of suicides, drownings and boat accidents on the lake." Baggett confirmed that some victims have never been recovered.[119] Haunting photographic evidence of what lies beneath has been found in old images taken by the USACE.

In the sad process of preparing the land for the lake, a series of eerie images was preserved. The black-and-whites showed buildings before they were destroyed. They include an apple cider stand looking as if it were still in business. A couple on their homestead. A dirt track that was filled on

Cider stand belonging to Isabelle M. Coffee. (J-1046). *Courtesy of Robert D. Coughlin and the U.S. Army Corps of Engineers.*

Saturday nights along with a deserted concession stand and ticket booth. A homestead, a racetrack, a family displaced—all captured in a few black-and-white pictures. Foreboding photos hinting about what was ahead. You can hear the wind blowing and kicking up red dust and rusted tin roofs no longer in need of repair. Doors slamming by themselves and creaking open on their own. The sound of desolation was not what Sidney Lanier heard as he penned his poem about the river.

Lanier wrote about the shadows and the darkness in the lyrical "Song of the Chattahoochee." Do those shadows remain? Is there a song still playing across the hills and the drowned valleys? Or has the music stopped? Lanier was convinced that while the South has changed, nature would never change. What would he think of the lake named in his honor, the sacrifice of the free flow of his beloved Chattahoochee? Lanier haunts this place, and his unsettled soul now knows that even nature can be disturbed like his homeland was after the Civil War. The natural flow was disrupted, and "The Song of the Chattahoochee" plays like a dirge.

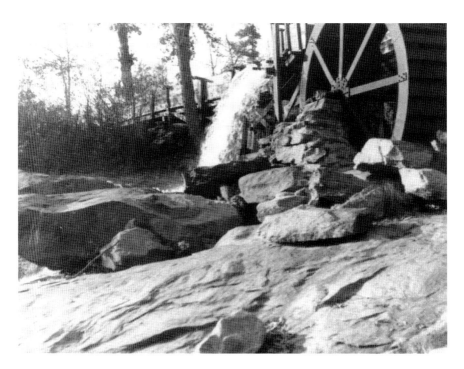

E.W. Scales's home and mill (A-100). *Courtesy of Robert D. Coughlin and the U.S. Army Corps of Engineers.*

E.W. Scales's front porch (A-100). *Courtesy of Robert D. Coughlin and the U.S. Army Corps of Engineers.*

Fishing downriver of Buford Dam, June 2017. *Author's collection.*

Fifty Years Later

Lloyd Cecil Martin remembered the day the river died. As a boy, Martin plowed crops in the rich bottom land of the Chestatee River now covered by the waters of Lake Lanier. "One day it ran. And the next day, it stopped." The Chestatee and Chattahoochee are the feeders supplying the reservoir.

Martin grieved over the loss. He missed the lifestyle and the valleys of Hall. He reflected, "You can't imagine how pretty it was. Fertile, black soil. Plentiful rabbits, squirrels and fish. Few people. Fields known by name, such as Jays Bottom and Castleberry Bottom."[120]

Watching the 1951 political groundbreaking for Buford Dam, Martin's grandfather said, "You need not worry. That dam here will never back water." Martin's father agreed, "Nope."[121]

The lake claimed more than fifty-six thousand acres, and more than seven hundred families were displaced. Many acres of that land belonged to the Martin family. The water rose and covered their fields. Martin's father left a large harrow in one of the fields. They would no longer need it. Now it is buried in over twenty feet of silt. Martin said, "I never did like the lake, and I don't like it now."[122]

5

LAKE HARTWELL

1962

The Hartwell Dam and Lake has prevented over $101,998 million in flood damages since 1962.
—*U.S. Army Corps of Engineers*

Eliza Brock was seventy-eight years old when she confronted the men clearing the land for Hartwell Dam with her daughter and a rifle. It was 1956, and the contractors had just started clearing her 103 acres. Brock and her daughter refused to allow them to clear her property. According to the USACE, "It seems that Savannah District Real Estate Division had purchased her deceased husband's share of the land, but had only presented her a formal 'declaration of taking' from the Corps, to which she had not agreed. Therefore, she still possessed a one-half interest in the 103 acres."[123] Brock settled out of court for $6,850.[124] She may have been the only person in Georgia who owned land jointly with the federal government.[125]

Lake Hartwell was built with other protests and controversies that stopped progress. When it was over in 1963, the reservoir covered 56,500 acres and involved the relocation of two miles of the railroad and the demolition of two railroad bridges. New state highway sections were built totaling 19.6 miles along with nine sections of county roads totaling 12.7 miles. The Corps built nine new bridges. The other controversy involved the border state and Clemson University.

Clemson was concerned the new dam would flood the university's athletic fields. Construction stopped until both sides found a compromise. The university built dikes to prevent flooding on its fields. The irony is that

without Hartwell Dam, the flooding would have been far worse. According to the USACE, "The Hartwell Dam and Lake has prevented over $101,998 million in flood damages since 1962."[126]

Another part of South Carolina was drowned by Lake Hartwell. The lake creates a border between Georgia and South Carolina on the Savannah, Tugaloo and Seneca Rivers. Andersonville, South Carolina, was a lost town before the lake because water transportation failed and the railroad bypassed it. In 1962, Hartwell Dam drowned all but four hundred acres now called Andersonville Island. Artifacts and overgrown roads on the island are the only signs that the town existed.[127] Mrs. Brock was not the only woman who left her mark on the Hartwell area.

ISSAQUEENA

The area where Lake Hartwell was built is rich in Cherokee history. Many of the streams and rivers have Indian names. Issaqueena, a Cherokee princess, named the streams. As she journeyed, she would mark her travel by naming streams for the miles she covered. Creeks that are now part of Lake Hartwell were named Six Mile, Twelve Mile, Twenty-Three Mile and Twenty-Six Mile Creeks. Before and during the Revolutionary War, the region was a hotbed of anti-British activity.[128]

NANCY HART

Eliza Brock was not the only Georgia woman to hold her ground with a firearm. Lake Hartwell is located in Hart County, named for the famed Nancy Hart.

Nancy Hart, the fearless revolutionary heroine, allegedly held off and killed six British Tories in the late 1700s. Historian Thomas Scott wrote about Nancy Hart in *Georgia Women: Their Lives and Times*, attempting to separate fact from fiction.

Scott asserts that Nancy Hart existed, but nothing about her exploits "appeared in print until fifty years after the Revolution, and many Georgia historians of the nineteenth century either didn't know of them or chose not to include them in their texts." The "War Women" were part of the Georgia

narrative in the middle of the nineteenth century—even a group of women in the Civil War called themselves "Nancy Harts."[129]

The British occupied Savannah during the Revolutionary War. Scott said, "Savage guerrilla warfare raged in the Georgia/Carolina backcountry." Those loyal to the Crown, the Tories, fought those loyal to the new government. In this context, Nancy Hart's legend began.[130]

Her work as a spy and American Patriot involved putting on men's clothing, going into a British camp and acting crazy. Hart could pull it off because she is rumored to have been tall, with manly qualities. Seven inspiring stories have survived. The tales may be fictionalized, but here are two of the best plausible stories about Nancy Hart.

In the first story, Hart was at home with her children, sitting around a fire and boiling a large pot of soap. While Nancy stirred, she was telling her children the latest news of the war when she noticed someone "peeping through the crevices of the chimney." Without missing a beat, Hart proceeded to tell exaggerated accounts of the Tories. Continuing to stir, Hart waited for the snooping eye to reappear. When it did, she filled the ladle with boiling soap and threw it through the crevice, scalding the eavesdropper. As he screamed, Nancy had fun and taunted him as she bound him fast as her prisoner.

Elizabeth Ellet wrote about Nancy Hart in the 1830s, referencing old-timers as her sources:

> *Six Tories from Augusta entered her house and ordered a meal. While they sat drinking she told her 12-year-old daughter, Sukey, to run off and warn her husband of the intruders. Nancy then managed to slip two of the men's muskets through a hole in the wall before they caught her with the third one in hand. One of the men rushed her, and she used the musket to kill him. Sukey returned to pass her mother a second musket, with which she wounded another Tory. While she covered the rest of the party with the third weapon, her husband arrived with a posse of neighbors, and the surviving Tories were hanged.*[131]

E. Merton Coulter, a history professor at the University of Georgia, was suspicious of this story until he investigated. He discovered that during a railroad excavation on the site of Nancy's cabin, six skeletons were uncovered.[132]

Georgians are proud of Nancy Hart. They named the county next to Hart's home (Elbert County) after her as well as a highway and Lake Hartwell.

POPULAR LAKE

The millions of people who visit Lake Hartwell do not know the hidden history of the area. Built between 1955 and 1963, with 56,000 acres of water and a shoreline of 962 miles, it is one of the largest and most popular public lakes in the Southeast. Recreation was not the first purpose of the lake. Hartwell was originally authorized for hydropower, flood control and navigation.

The USACE built and manage three lakes on the Savannah River: Hartwell, Richard B. Russell and J. Strom Thurmond. These lakes are responsible for maintaining water supply and water quality needs of the

Left: Before 1963, the Memorial Bridge was the main way to get over the river to Clemson. The bridge was covered by Lake Hartwell. *Alan Cutts, tigerpregramshow.blogspot.com.*

Below: During the drought of 2008, the Memorial Bridge resurfaced. *Alan Cutts, tigerpregramshow.blogspot.com.*

Savannah River from below Thurmond Dam all the way to Savannah, Georgia, and the Atlantic Ocean. The Savannah River forms at the confluence of the Tugaloo and Seneca Rivers, 7.1 miles above the Hartwell Dam.

The reservoir covered 56,500 acres and merited the relocation of three sections of railroad totaling 2 miles; the demolition of two railroad bridges; construction of six sections of new state highways totaling 19.6 miles and nine sections of county roads, totaling 12.7 miles; nine new bridges and the raising of four existing bridges; and the relocation of two power transmission lines.

One of the drowned bridges that resurfaced during the 2008 drought was the Memorial Bridge. Lake Hartwell spans two states, and this bridge joined South Carolina and Georgia next to Clemson University. A plaque on the old sunken bridge reads, "Memorial Bridge dedicated to the men of Clemson College who gave their lives during the War."[133]

6

CARTERS LAKE

1977

Progress can be a dreadful thing.
—James Dickey

Christopher Dickey does not remember much about his father's adventures, but he does recall the night he came home from a trip down the Coosawattee. Christopher was just a little boy the night James Dickey and two friends returned "hurt and scared." Later, Chris heard his father talk out the plot to *Deliverance* into a tape recorder.[134] James Dickey said his novel was inspired by his experiences on "four or five different rivers, including the Coosawattee, Chattooga, and Chattahoochee."[135] When asked if the story had any basis in truth, Dickey responded, "I can't say. The statute of limitations hasn't expired yet."[136]

The mountain people around the Coosawattee were rough. In the 1950s and 1960s, it was a different place. In 1995, Claude Terry, a canoeing technical advisor for *Deliverance*, said, "You could get killed at the drop of a hat. But today, people have forgotten that."[137] Terry said Dick, Lewis King and Al Braselton planned a trip down the Coosawattee. Dickey and Braselton canoed, and King drove downstream to pick them up.[138]

King was navigating to the river on a remote logging road and stopped to look at his map. Out of nowhere, an armed man and his son appeared and asked King what he was doing. Moonshine was big business, and strangers were suspected of being "revenoor," or revenue officers. The father instructed his son to take his gun and show him the way to the river. If no one came down the river, he told his son to come back alone.

Terry said, "Afraid that Dickey and Braselton might already have passed downstream, King sweated bullets until, an hour or two later, they rounded a bend in the river."[139] This may have been when Dickey began writing his bestselling novel and blockbuster movie *Deliverance*.

The fictional Cahulawassee River doubles for the Coosawattee. Dickey wanted to paddle down one of Georgia's wildest rivers, the Coosawattee, before it was gone. He gathered his friends for a weekend that would change him forever. Daniel M. Roper, editor of *Georgia Backroads* magazine, recounted a trip organized in 1974, just four months before impoundment, for a group of state dignitaries. They wanted to experience the river before it was gone. The DNR guide recalled, "This nearly resulted in a disaster."

It rained the day before the launch; the river was rising, and the rapids were faster. The guide dropped his group off and went downriver to pick them up. "None of them ever made it down the river. We found them alongside the road and staggered out of the woods until nearly midnight."[140] They were overcome. The river's power shook the novices. They only recovered three of the five canoes.[141] The river was wild and torturous. The land around the Coosawattee was rough and raw with deep valleys and lush snaky banks.

THE DAM

The USACE began the impoundment process by building Carters Dam, which would stop the swiftly flowing Coosawattee and create Georgia's deepest reservoir, Carters Lake. That was the landscape before Georgia's need for power and control began in the early 1900s.

As electricity became a necessity and no longer a novelty, the New South was in need of cheap ways to produce power. Before the dam, there were falls that were ten to fifteen feet high—now submerged under four hundred feet of water—and the waters do not run wild and strong.[142]

Flood control also was an issue. A Calhoun resident said, "If Carters Dam broke, it would flood Calhoun." It was easy to brush the shocking statement off as local lore. But the statement is true in theory. Calhoun is on a plain, flat and level; flooding would be an issue. Flooding was a problem until Carters Dam began controlling the wild rivers.

The area around the Coosawattee before the lake has some interesting stories. As a boy, my husband watched this reservoir during construction. He was struck by the depth and the height of the walls. On quite a few dates,

we would find our way to one of the dams; Carters must have been his favorite—he was there when it was born.

He would tell stories about an old moonshiner at Carters Quarters, now inundated with hundreds of feet of water. He remembered his Paw Paw Charlie stopping by a local store; he came out with a package and put it in his trunk. "What's in the package, Paw Paw?" young David would ask. "Never mind about that, boy," Charlie would say as he scratched his ear with his car key and then started it up. David didn't understood what was in the package until he grew up. His Paw Paw bought a jug of moonshine.

Coosa

Long before moonshiners and crazy mountain people lived in the Carters Lake area, there was Coosa, spelled variously as Kusa or Cosa. Jim Langford, an expert on North Georgia Native Americans and archaeologist, confirmed that the Indian capital village existed where the lake stands today. Along the banks of the Coosawattee, one of the most turbulent rivers of North Georgia, the people of Coosa thrived.

Coosa was the name of the village and the entire chiefdom that stretched over several hundred miles from Knoxville, Tennessee, to Montgomery, Alabama. These Indians were ancestors of the Creek. The name Coosawattee means "old place of Coosa" in Cherokee.

Langford suggested DeSoto's visit was the beginning of the apocalypse for the Coosa people. The Spaniards were looking for gold but deposited disease along the Coosawattee and the capital city. The chief of the Coosa people, the paramount chief, received the strangers into his territory.

Langford described the paramount chief, dressed all in white feathers and carried by his men, coming down from his mound. He was so special that his feet were never to touch the ground. So, he lived on a mound and was carried by his servants. Despite the warm welcome, DeSoto was not a nice guest. He captured the chief and other relatives, parading them as prisoners through the streets of Coosa. He took prisoners on his trek to Mexico. He left the area as well as a deadly legacy.

Twenty years after DeSoto's visit, birthrates and population had dropped. The villages were vacant. Eventually, these once great people died out. By the 1600s, 90 percent of the native population had died or moved downriver looking for family, food and transportation. Coosa was a remote place. This

left most of North Georgia abandoned until about 1750, when Cherokees from North Carolina and Tennessee drifted into the area. They were trying to get away from white settlers who were pressuring them to leave.

The Coosawattee Valley then became the capital of the Cherokee Nation. The capitol village was Oostenauleh, located a few miles upstream from the New Echota. That capitol moved to the newly created town of New Echota in about 1817.[143] The area around the Coosawattee was rugged, with steep mountain walls and deep valleys. It remained remote and natural until the early 1970s.

PRE-DAM DAYS

Editor of *Backroads Georgia* Daniel M. Roper said, "Beautiful Carters Lake cannot disguise the serpentine route once taken by the Coosawattee."[144] Roper described how the Ellijay and the Cartecay Rivers combined in downtown Ellijay and fell west through the mountains. Before it was dammed, the river cascaded over a "series of ledges and shoals in the Coosawattee River Gorge."[145] Through a narrow cleft, the Coosawattee once carried runoff from 376 square miles of watershed into the flatlands of northeast Calhoun or "The Great Valley."[146] The river often threaded Calhoun and Rome with extra water before the impoundment.

In 1945, Congress enacted legislation that began the process of clearing land and building Carters Dam, then the impoundment of what is now the deepest reservoir in Georgia, Carters, as it is known by the locals. The project was completed in 1970, the same year James Dickey published his bestselling *Deliverance*.

This disturbing tale of survival on the fictional Cahulawassee River in North Georgia began with Dickey's love for the natural rivers such as the Coosawattee. Dickey was compelled to write the novel after taking a trip with some friends down the Coosawattee just before it was dammed. He was mourning the loss of this Georgia treasure. Though the Oscar-nominated movie that followed the popular novel was filmed on another wild Georgia river, the Chattooga, the connection to the Coosawattee and other dam projects was undeniable. And the people were similar.

The characters Dickey created bore a striking resemblance to the people who existed in this wild and dangerous region for hundreds of years. The people of Coosa did not survive the disease that white man brought. And the old mountain people of the Coosawattee could not stop the dam. Though

it is still a remote place and the area around the lake is managed by the USACE, the wonderful isolation is gone. This same scene had played out throughout North Georgia. At Allatoona, Chatuge, Nottely and Lanier, the wild wilderness was washed away for progress and power.

Deliverance of the Chattooga River, Forever Free

The movie is iconic. The movie's connection with the land was real; the jagged rocks suggest a menacing tale. The movie's director, Boorman, and his cinematographer, Vilmos Zsigmond, desaturated the lush green along the river to give it a foreboding feel. Faber of the *New York Times* wrote about the film's imagery: "The wilderness they see is strange, inviolable, unearthly, never romantic or reassuring."[147] The filming on the Chattooga River matched what the Coosawattee was before it was impeded by progress.

Deliverance was about survival at any cost. Georgia had been on a dam-building spree because of its need to survive by producing more power and control over our natural waterways. Boorman said, "It's about a river that's going to be dammed and killed; four men want to canoe it before the river disappears." Boorman wanted the first shot of the river to be very powerful: "Behind it, there is this notion the river is going to disappear and its beauty lost."[148]

"Progress," said James Dickey, "So called, can be a dreadful thing....The damming of the Coosawattee began before Americans became conscious of the environment. It was a time when no one doubted the wisdom of converting a remote gorge into a source of hydroelectric power, flood control, and recreation."[149] Later, Dickey contributed to the efforts to save the Chattooga River from the same fate as the Coosawattee. With the help of then-governor Jimmy Carter, who took a ride down the Bull Sluice of the Chattooga River in a tandem canoe, the river will forever be preserved as a "Wild and Scenic River."[150] Jimmy Carter would remember this experience.

What difference does it make to tell these stories about the rivers and the ghost towns beneath the lakes of North Georgia? On the Georgia Rivers website, writer, naturalist and environmental activist Janisse Ray said it best:

Story is transformative. People change because of stories they read. Story is powerful. We need to tell stories of a world in which the things that matter

Coosawattee River near Carters Lake. *Author's collection.*

Coosawattee River near Carters Lake was once a wild waterway that inspired the movie *Deliverance*. *Author's collection.*

Carters Lake Reregulation was once the Creek capitol, Kusa. *Author's collection*.

are main characters. We need to tell new stories of how to navigate the world, how to take care of the earth, and how to love each other. Because if we don't tell our stories, corporations will tell them for us. And that won't be pretty for the future of the planet or the human community.[151]

7

Richard B. Russell Lake

1985

Relocation of cemeteries could cause a hardship on relatives of the deceased.

Richard B. Russell, or Russell Lake was one of the last of the dam projects. After years of practice, the relocation was a smoother process. The government understood by the 1970s the psychological impact on the people. Under Public Law 91-646, the government had to provide relocation assistance and advisory service.

The country changed in the 1960s, and environmental issues were now a concern. The way dams were built started to change. The USACE started including environmental studies in its projects. In an environmental impact statement, the TVA concluded that the Russell "project benefits outweigh the adverse effects."[152]

The University of Georgia conducted archaeological studies on the Russell Lake area before the dam was closed in 1970. Researchers found prehistoric and pre-ceramic artifacts that proved the area had a small band of archaic hunters. Three prehistoric fish traps were located within the Savannah River channel at Cherokee Shoals and Trotters Shoals. Other items found in the lake basin included a farm, a mill site and a nineteenth-century ferry crossing.[153]

A Different Lake

Richard B. Russell was designed to support hydropower, recreation, water supply, flood control and fish and wildlife conservation. Originally called Trotters Shoals Lake, it was soon renamed for Senator Richard Brevard Russell Jr. Russell was a devoted advocate for hydropower and the TVA. Russell Lake differs from the other two Savannah River projects, Hartwell and Thurmond. The lake looks different. It has 26,650 acres of water and 540 miles of pristine shoreline. Compared to the Hartwell and Thurmond reservoirs, the Russell Project differs in not only size and appearance but also functionality. Here's what makes Russell Lake different.

The Russell project is designed to pump water upstream from the Thurmond reservoir. This produces hydropower, which is marketed to private electric companies via the Southeastern Power Administration to meet the region's peak demands for electrical power during times of high use. Peak power demands include hot summer afternoons and cold winter mornings. The Russell Dam is the largest USACE hydropower plant in the Southeast.[154]

The Corps explained,

> *The four pump-back units at Russell Dam are different from regular generators in that at night, when electrical power demands are low, they can operate in a reverse direction to pump water from below the dam back upstream into Russell Lake. Then, the next day when peak power demand occurs and the price of electricity peaks, the additional water that has been stored overnight can be used to generate electricity.*[155]

Another unique feature is the conservation storage. This reservoir did not need storage. Hartwell has thirty-five feet of conservation storage, and Thurmond has eighteen feet of conservation storage, while Russell only has five feet of conservation storage. Russell's shallow, five-foot conservation pool always appears full, even during drought.[156]

The final unique feature of Richard B. Russell Lake is the limited private shoreline use. All water resource projects built after December 13, 1974, prohibit private use of public lands. The shoreline is undeveloped except for a day-use area made by the state parks. No private boat docks, ramps, gardens, buildings, walkways, mowing or clearing of brush are permitted. The shoreline looks untouched compared to Thurmond and Hartwell, which have highly developed shorelines.

PART II
THE GEORGIA POWER LAKES

8

THE GEORGIA POWER COMPANY

Visionary James Mitchell toured Alabama's and North Georgia's rivers for two weeks. The entrepreneur wanted to build the first electric grid in the South. He came upon a powerful river, and looking over the bank, Mitchell witnessed rapids rushing down and said, "It's the best damn site I ever saw in my life."

Mitchell saw money and power in those rivers, but he was the big-picture man. He needed someone to help him accomplish his vision, so he found an Alabama lawyer to begin the process that birthed the Southern Company. Georgia Power is a subsidiary of the Southern Company.[157] Between 1890 and 1925, hydroelectric power—water, not fossil fuels—was the most important energy source in the New South. Mitchell wanted to electrify the South and usher in a new era. Rivers were in abundance in North Georgia.[158]

Before joining the Southern Company in the 1920s, the Georgia Power Company brought Atlanta power in 1884. Georgia Power has a strange lineage with five different name changes and five different companies.[159]

Georgia Railway and Electric Company built hydroelectric power dams in the early 1900s for the cheap, clean power. By 1910, the company had impounded Lake Jackson and, by 1912, Tallulah Falls Lake. Georgia Power continued to build dams across Georgia rivers for power generation until the 1980s. The last construction was stalled, but in partnership with Oglethorpe Power, Georgia Power completed Rocky Mountain Recreation and Public Fishing Area and four reservoirs next to Berry College for power generation.

The Georgia Power lakes impound a total of 57,880 acres and collectively encompass 1,376 miles of shoreline. Georgia Power operates the greatest number of corporate-owned lakes. The Georgia Power Lakes of North Georgia form a chain beginning with Lake Burton and ending with Lake Yonah, with Tallulah Falls Lake in between. The configuration and connectivity might remind one of the Great Lakes of the North; unlike those bodies of water, the Great Lakes of North Georgia are reservoirs and not natural lakes. These lakes were created for hydroelectric power, with recreation as a byproduct.[160]

The lakes on the Tallulah River and its tributaries have, for the most part, been ignored archaeologically. Lake Burton, Lake Seed, Lake Rabun, Lake Tallulah, Lake Tugalo and Lake Yonah were constructed prior to federal regulations requiring reservoirs to be investigated by archaeologists. Since their construction, some have been subject to limited archaeological studies required for government re-licensing.[161] This oversight resulted in lost history about this region. The Native Americans who lived in these impounded areas are ghosts and their culture forgotten.

9

TALLULAH FALLS LAKE

1911

The people of the state were asleep.
—an Athens newspaper editor

We will never experience Tallulah Falls the way it once was. Before 1913, Tallulah Falls was a series of four main cascades and several smaller rapids that dropped approximately 350 feet over a mile's progression. The *New Georgia Encyclopedia* described the falls thus:

> *After gathering speed through the Indian Arrow Rapids at the head of the falls, the Tallulah River shot down L'Eau d'Or, a forty-six-foot-tall cataract. Tempesta, estimated at eighty-one feet, was the second fall, followed by the largest cataract, Hurricane, which dropped ninety-six feet. Oceana, approximately a forty-two-foot drop, was the final major falls. The gorge through which the river cut created steep cliffs and rock outcroppings that provided excellent observation points and added to the scenic beauty of the falls.*[162]

That was then.

Left: Tempesta Fall, Tallulah Falls. *Photo by Huron H. Smith, the Field Museum Library.*

Right: Tallulah Falls. *Photo by Huron H. Smith, the Field Museum Library.*

EARLY TOURISM AT TALLULAH

Like most land in North Georgia, the Cherokee Indians lived in the area surrounded by Tallulah Gorge. They called the falls *Ugunyi*, but Europeans came in 1820 and named them Tallulah. The Cherokees were a little afraid of the falls and avoided getting close to them. The white settlers were inspired and wrote about the beauty in travel books and newspapers. They called Tallulah the "Niagara of the South." And the tourists came.

In 1882, an extension of the railroad made travel from Atlanta shrink from days to hours. According to a Stephens County History site, "Tallulah Gorge Railroad first brought one thousand a year that soon turned into thousands a week. On Sundays during the summer, the twice daily railroad excursions would expand to 5, bringing 2000 people on that day alone."[163] Seventeen hotels and boardinghouses sprang up around the falls. One of the first was the Cliff House Hotel, erected by Athens businessman Rufus L. Moss Sr. He was the director and a

trustee of the Northeastern Railroad and co-founder of the booming town of Tallulah Falls. Georgia had electricity, but the need for more was growing. The walls of Tallulah Gorge were a perfect place to anchor a hydroelectric dam.[164]

DAMMING THE FALLS

Georgia historian E. Merton Coulter said in *Georgia Waters*, "By 1913 Tallulah Falls had been destroyed and on September 1913 18,000 horsepower of electricity went strong out of the defunct Tallulah Falls over the wires to Atlanta."[165] A few months later, the output increased to 85,000 horsepower with the addition of more generators.

The Georgia Railway and Power Company (Georgia Power) proposed a dam on Tallulah Falls in 1914. For good press, the company invited the Georgia Weekly Press Association to Tallulah Falls for a barbeque. It worked. Newspapers defended the project: "[F]ar from being robbed

Five men holding axes, machetes and a measuring device, probably from Blue Ridge. *Photo by Huron H. Smith, the Field Museum Library, CSB29579.*

of its scenic beauty by reason of the great power development, this country is more beautiful than ever."[166] The propaganda continued, as the press predicted that it would "revolutionize the manufacturing map of Georgia." Journalists wrote about how small towns would pop up all around Tallulah Falls. The *Dahlonega Nugget* said that the Tallulah power plant would employ many and feed hungry children. Enthusiasts even called those streams of water a *waste*. They were doing no good. The power development did not detract from the scenic beauty but added to it. It would become a natural attraction.[167]

As construction began in 1917, workers came, and another rail line brought workers and supplies on a small-scale train called a "dinky."

Onlookers marveled at the engineering. Others came to appreciate the beauty for one last time. Coulter recorded one admirer's comments on the falls: "Witch's Head is gone, Hawthorne's pool is filled with rocks, trees, and the shrubbery have been cut down and the entire face of the landscape changed."[168]

A spur rail line was run from the Tallulah Falls Railroad near Wiley to bring supplies for building the dam and hydro plant. The rails were smaller in scale, and the locomotives were called "dinky" by the workers. *Courtesy of the Rabun Historical Society.*

CC&P Railway log train with wood-burning stack, 1910. *Photo by Huron H. Smith, the Field Museum Library, CSB31339.*

An Athens editor observed that "the people of the state were asleep."[169] He reminded readers that both Georgia and the U.S. government could have saved Tallulah Falls, but the opportunity was lost.

For a brief time in the early 1900s, Niagara Falls and Tallulah Falls existed in parallel circumstances. The great Niagara was in danger of desecration by hydropower in the name of progress. At the same time, the Niagara Falls of the South, Tallulah Falls, shared the same fate. In 1910, a Niagara Falls conservation effort saved the northern falls. This encouraged Tallulah's supporters.

The power company saw progress and dollar signs while others saw a natural wonder that was not renewable. Enter Helen Dortch Longstreet.

HELEN DORTCH LONGSTREET

Mrs. Longstreet was a fighter. Her prior campaigns included trying to restore her husband, Lieutenant General James Longstreet's, reputation. Lieutenant General James Longstreet was Robert E. Lee's trusted advisor. Lee referred to Longstreet as his "Old War Horse." But according to the Civil War Trust, "[N]o Confederate officer is surrounded by more controversy than James Longstreet….After the war, Longstreet became the target of many 'Lost Cause' attacks." He was accused of losing at Gettysburg and other battles. After the war, he alienated many southerners.[170] For the rest of her life, Mrs. Longstreet attempted to clear his name. She was a progressive reformer before she had the vote.

Women were not allowed to vote in the early 1900s, but Helen Longstreet, along with other Georgia women like Rebecca Latimer Felton (our first woman U.S. senator),[171] raised money and gathered support to wake up the sleeping state and warned people that they would be losing at Tallulah. In 1911, Longstreet organized the Tallulah Falls Conservation Association to stop Georgia Power from building the dam. She wanted the state to turn the area into a state park. Longstreet would not give up; instead, she pushed ahead with her plan to save Tallulah.

She went to court and the state legislature. She wasn't allowed on the floor. In 1912, she lobbied the Georgia state legislature and forced the attorney general to bring suit against the Georgia Railroad and Power Company. A year later, the power company prevailed in a jury trial in Rabun County and in a subsequent appeal to the state supreme court. Longstreet won a battle, but in the end, like her husband, she lost the war.

Longstreet continued to be a progressive reformer, moved to the Virgin Islands and waged other wars on poverty. Sadly, in 1957, Longstreet was

Huron H. Smith in bowler hat, standing on a rock overlooking a stream or mountains, Tallulah Gorge, 1910. *Photo by Huron H. Smith, the Field Museum Library, CSB31267.*

admitted to the Central State Hospital in Milledgeville for mental illness. She died in 1962 at the age of ninety-nine.[172]

In some way, Longstreet's fighting spirit lives on. In 1996, the Jane Hurt Yarn Interpretive Center opened. The fifteen-thousand-square-foot state-of-the-art facility is one of the best in the country and features comprehensive displays on the history and wildlife of the gorge as well as local and regional information.

In 1937, tourism returned when the Georgia (later Chattahoochee) National Forest opened in 1937, "bringing more visitors to the area than had been seen the previous 25 years since the dam was built at Tallulah Gorge." A state park, one that Longstreet wanted for Tallulah, exists with "some of the most diverse facilities of any state-run park."[173] Trails surrounding the gorge provide spectacular views of the upper gorge, including Tempesta and L'eau d'Or (Water of Gold) Falls.

Today, everyone who visits Tallulah remarks on its beauty, but we can never know its original majesty. A long time ago, before the dam, visitors were speechless. They could not find the words. According to Coulter, one writer tried to describe what he saw on a visit and had to put down his pen. He said, "You must go and see it for yourself." The best description comes from one crusty gawker, who said, "God Almighty…"

Great Lakes of North Georgia

Tallulah Falls Lake is a 63-acre reservoir with 3.6 miles of shoreline located in the northeastern corner of Georgia in Rabun County. It is the fourth and smallest lake in a six-lake series created by hydroelectric dams operated by Georgia Power that follows the original course of the Tallulah River. The series starts upstream on the Tallulah River with Lake Burton followed by Lake Seed, Lake Rabun, Tallulah Falls Lake, Lake Tugalo and Lake Yonah. Georgia Power considers the lake full at a surface elevation of 1,500 feet.

Just like Niagara Falls and Tallulah Falls were connected in spirit, the idea of a series of connected lakes is similar to the Great Lakes. Tallulah was changed, and the Great Lakes of North Georgia are human endeavors.

10

LAKE RABUN

1915

*We never grow too old for the joy we find there or
for the wisdom and forgiveness of water.*
—*Philip Lee Williams*

At the beginning of the twentieth century, Rabun County was isolated from the rest of Georgia and the outside world. Everything changed when a railroad was built. The railroad brought loggers and the Georgia Railroad and Power Company. This is an area that values its history, and the Rabun County Historical Society has done an excellent job with images and stories of the region.

Gold was discovered in Rabun County in the 1820s on many of the creeks feeding the Tallulah River from the west. However, no gold vein was as large as the ones found at Auraria (near Dahlonega) in Rabun County. The real value in this beautiful land is the seclusion. Even with the construction of a reservoir, the pureness remains.

Lake Rabun, the third Georgia Power project, is formed by Mathis Dam over the Tallulah River. The lake covers 834 acres and has 25 miles of shoreline, second only to Lake Burton. The dam's construction started in 1915, but it was not closed until ten years later. Georgia Power had to build a mile-long tunnel from Mathis Dam to the Tallulah Falls power generator at Terrora.[174] The Terrora power plant was built downstream to take full advantage of the 90-foot drop in altitude, and Georgia Power built a mile-long tunnel through solid rock to bring water from the dam.[175]

Lakemont grew, as hundreds of workers were brought in from outside the county to help complete the huge construction project. Residents began settling along the river's shores. In the 1920s, many property owners used boats to reach their homes along the lake. The roads were poor or nonexistent.

Augustus Andreae, a German immigrant and silk merchant, moved to the mountains for his health. He purchased land along the Tallulah River near Tallulah Falls before the dam was built. He exchanged land with Georgia Power when the company dammed the river to create Lake Rabun. At one time, Andreae owned much of the land around the new lake. He then sold land on the shores of the new lake to wealthy Atlanta families for summer getaway homes.

Andreae loaned M.E. Crow money to open a hotel in Lakemont, but Crowe sold it back to Andreae during the Depression. Today, the Lake Rabun Hotel is still open and the only surviving lodge on a North Georgia lake.

According to the Rabun County Historical Society, "In order to construct Nacoochee Dam which impounded Seed Lake, Georgia Power Company used huge barges to ferry construction materials and tools up the lake. This boat towed the barges across Lake Rabun."

Eight miles north of Tallulah Falls, an old school was abandoned in 1914 because the waters of Lake Rabun were coming. Georgia Power paid $400 for the building. The school was moved to a new building and named Flat Creek School.[176]

Forgiveness of Water

The North Georgia lakes, especially Georgia Power's sister lakes, bring out the poets and artists to reflect on existence and reality. Philip Lee Williams, four-time Georgia Author of the Year, wrote:

> *Almost a century ago, Georgia Power built a series of six small lakes on the Tallulah River. Like all such impounds, the lakes came with human pain. Area residents, even one whole town, had to move. But a century later, the lakes have a gorgeous inevitability about them. On any summer's day, the giggling of children can turn into the clarinetty squabbling of waterfowl across their placid waters.*[177]

The ten miles of deep valley along the Tallulah River was a perfect setting for this hydropower reservoir, but something else was created: a private getaway for many Georgians. Williams commented that every time he returns to Rabun, he is reminded of what Ernest Hemingway said about Paris, "We always returned to it no matter who we were or how it changed or with what difficulties, or ease, it could be reached." He continued, "The same is true for Georgia's lakes. We never grow too old for the joy we find there or for the wisdom and forgiveness of water."[178]

The ten-year construction period of Lake Rabun involved many people in construction and land acquisition. Relocating people, buildings, churches and cemeteries is never a painless process. The scarring of the heavily forested landscape and the taming of the Tallulah River would not happen today in an era of environmental awareness. The past is done, and the Tallulah River is not returning from its un-dammed state. Yet redemption is in reclamation and recycling the land into a new beauty—a place to reflect and recreate. On a peaceful cove, lapping waters flood the soul.

11

LAKE BURTON

1919

It just ruined their lives. They never were satisfied.
—Willie Elliott

In 1902, A.J. Warner, a former Union general, came to Rabun County to harness the electricity in the water. He was a visionary ahead of his time. He died broke. Warner would never see the progress he envisioned. The problem with selling electricity is, you have to have a market as well as lights and appliances that would use electricity. Enter the Georgia Power Company.

Between 1911 and 1920, Georgia Power Company acquired 5.6 percent of the land in Rabun County, including the town of Burton, which straddled the Tallulah River. In order to build the first hydroelectric power dams on the Tallulah River, land had to be acquired. A large portion of Rabun County would become a public entity. The remaining land would be scant and expensive—too expensive to buy back. Inherited lands were split and sold as smaller lots that families could not afford.[179]

"It just ruined their lives. They never were satisfied," Willie Elliott recalled when Georgia Power bought all the property in her hometown of Burton. "I don't think they got anything [like] it was worth for what it did to the community." Elliott remembered the days at the end of 1919 when the dam closed and flooded her town. She was interviewed for *Foxfire 10*: "All I remember [about the flooding after the dam was constructed] is that they didn't tear down the house, it was left standing. We took all the belongings,

John M. Burton (1845–1922), son of Jeremiah Burton, at one point owned one thousand acres along the Tallulah River. While it is not known when Burton was named for him, 1890 maps show the name Burton. *Courtesy of the Rabun Historical Society.*

of course. I remember my father making the remark that they moved out the last load of furniture just before it got high enough to flood what he had in the wagon."[180]

BURTON BEFORE

Before December 22, 1919, Burton was the second-largest town in Rabun County, with two hundred citizens.[181] Rabun County, Georgia, was created one hundred years and a day earlier from Cherokee lands by the Georgia legislature and named for William Rabun, governor of Georgia.[182] Rabun County is the northeastern-most county in North Georgia. Beautiful tree-carpeted mountains surrounded Burton in an idyllic location. In the early 1800s, settlers found gold where Dick's Creek and the Tallulah River join; this is how the town formed.[183]

The town was prosperous, with residents living in large homes on both sides of the Tallulah River. The community had three general stores, a sawmill, a church/school building and a post office. The general stores would have had difficulty keeping their shelves full. According to the Rabun County Historical Society, "Any supplies had to be brought in with a day's wagon ride to Clayton or Tiger."[184]

The Burton School was a one-room school that also served as a church. In 1914, there were seventy-eight children enrolled. According to some accounts, Rabun County spent about five dollars per year per student. There were blackboards but no textbooks.[185]

Music was important in Burton. Dr. John C. Blalock spoke about his early life in Burton, including singing conventions and music school. "A singing convention lasts all day!" He remembered singing school every year for two weeks. He said, "The teacher would call on you to see if you could sing, and he found right quick I couldn't even carry a note to the post office."[186] Blalock said the church bought an organ, and only one girl could play it. It was the only instrument in town. Other communities would come and borrow the organ for their services.[187]

General store at Burton. Burton's town center consisted of a church/school building and a general store that also served as a post office. Any supplies had to be brought in with a day's wagon ride to Clayton or Tiger. *Courtesy of the Rabun Historical Society.*

J.E. Harvey was the local entrepreneur who bought most of the land for the Georgia Power Company in Rabun County.[188] In a 1982 interview, published in *Firefox 10*, Dr. John C. Blalock explained what happened: "I'll give you the exact way it was bought, every bit of it. The power company first sent up three surveyors, all graduates of Tech, and surveyed all of this. The surveyors stayed at our [boarding]house two or three months, all the time they were doing it…they said they were surveying for the government. That's all they ever told anybody."[189]

Blalock continued to explain how "old man Harvey" went to Clayton and found out how much property tax everyone paid in Burton. He told Blalock's father that he was working for the government and that he wanted to buy the property for some sort of utility. "Mr. Blalock, I want to buy you out." Harvey told Blalock that he could live there the rest of the year, but they wanted them out by the next year.

Harvey and Blalock negotiated for his property on both sides of the river and his store. Blalock would not sell the materials in the store, worth $4,000. He could have gotten $25,000, but he asked for $9,000 ($224,112 in 2018 dollars).[190] Harvey went to every house in Burton in one day and made everyone an offer. Blalock remembered that "he got nearly all of them." Most were satisfied, but some felt swindled. They demanded more money—and they got it.[191] In all, sixty-five families sold property to create Lake Burton.[192] Another Burton resident shared:

> *Dad had a little farm down there. I don't remember how much land my family had then; the lake covered it up. That's what they done, you know. Water came to about eight feet over where we lived.…*[My dad] *took the money and went to Chechero and bought another homestead. All the rest of the people in the community done the same—one here and one yonder, to and fro. They just took up their beds and walked.*[193]

After the flood, one resident said, "The water rose so fast, the steeple of the church was seen floating in the lake for years."[194] Graveyards were dug up, and bodies were moved to a new cemetery. Protesters wanted graves left in place.[195]

Harvey was not the only one to benefit from dam projects. Many took jobs in construction and other public jobs. Mouths were fed as the mountain people learned new skills. They no longer lived in isolation. As new people came, they were exposed to the outside. Now they could travel and experience different places. The mountain people even did simple things differently. They ate store-bought bread and played league baseball.[196]

BURTON'S SACRIFICE

At one time, Lake Burton was the largest producer of power for Georgia. Now, the lake provides power only during peak periods for Atlanta. Lake Burton is a 2,775-acre reservoir owned and operated by Georgia Power. Lake Burton is 1,855.5 feet above sea level, making it the highest and first in a chain of six power producers in Rabun County: Lake Seed, Lake Rabun, Tallulah Falls Lake, Lake Tugalo and Lake Yonah.[197] Beyond energy production, Lake Burton creates new life.

If the residents of old Burton could see the purposeful beauty of Lake Burton, they would be proud of their sacrifice. Lake Burton has not only energized North Georgia but also revitalizes the natural environment. Lake Burton is rich with flora, fauna and fish.

According to the Lake Burton Civic Association, the area is known as the "vegetation cradle" of eastern North America and is home to more than 4,200 plant species. The magnificent mountains are dotted with wildflowers, herbs, vines and trees.

The Georgia Game and Fish Commission reported that the mallard duck is the most prevalent water fowl that winters in North Georgia. Other transient birds include Canada geese, wood ducks, loons, canvasbacks, sandhill cranes and great blue herons.

Campers in the area might like to know that bobcats and a large population of black bear live in the forest. Lake Burton forests accommodate the red and gray fox, white-tailed deer, raccoons, opossums, gray and flying squirrels, ruffed grouse and wild turkey. A fortunate visitor to the area may get a glimpse of the bald or golden eagle.

The streams feeding Lake Burton are stocked with spotted and largemouth bass, bluegill, crappie and yellow perch. The Lake Burton Civic Association reported, "Several spotted bass greater than four pounds have been found in DNR samples."[198] Lake Burton holds state records for walleye (eleven pounds) and yellow perch (two and a half pounds). White bass also reach near record breaking size.[199]

Burton's residents sold their homes, businesses and land at a sacrificial price. Lake Burton Dam closed on December 22, 1919, and the lake began to fill. Many were not satisfied and felt lost. But what could they do?

The lake was completely filled by August 1920 and has stayed at full pool ever since. As Lake Burton filled in eight months, the people relocated to higher ground. They would never know what the next hundred years would do to their magnificent land. The waters would

As Lake Burton rises, one piece of the town lies in ruins. *Courtesy of the Rabun County Historical Society.*

bring power to the growing metropolitan Atlanta. Thousands of people have enjoyed Lake Burton, and its sixty-two miles of shoreline provide many opportunities for camping, fishing, picnicking, boating and hiking. New plants, animals and fish thrive in and around the peaceful, cool waters. Burton is dead and buried, but with Lake Burton, this portion of North Georgia is born again.[200]

LAKE TUGALO

1923

A little city sprang up in the northeast Georgia wilderness. Recorded in the July 6, 1922 edition of the *Atlanta Constitution*, "Off in a wilderness that six months ago had felt the touch of the feet of a few humans, electric lights can be seen burning in scores of cottages."

The newspaper described a company village that popped up on the Tugalo River ahead of the dam construction.

> *This little city, sprung out of the wilderness, has been built to house the 800 to 1000 laborers needed to complete the great dam being built by the Georgia Railway and Power company to harness the power of the Tugalo river.*
>
> *The town has everything but paved streets that city civilization boasts, and in addition there is the cool, stimulating mountain air, the breezes that blow through he hills throughout the summer, and the most picturesque scenery that the south can claim.*
>
> *The labor employed at the Tugalo development will be largely negro and the town build for the negro laborers is declared to be a model of sanitation, comfort and convenience.*

The article boasted of broad streets on the crest of a hill overlooking the rushing Tugalo River and the slope down to the workplace. The houses were sized according to need. Small homes were for bachelors and larger ones for families. The company encouraged the families to keep the workers happy.

The Hardman House was constructed on the site of the Tugalo Construction Village by the Georgia Power Company sometime around the late 1920s. The house was the office of Dr. Charles Terrell Hardman (1888–1953), who served as the field surgeon for employees of Georgia Power's hydro-plants. *Courtesy of the Rabun Historical Society.*

The company also provided lighted streets and cooking facilities. Two mess halls provided meals for twenty cents. A movie show operated nightly, and the facility was repurposed for church services. The company store stocked luxuries like soda pop and gasoline for those who had cars. A physician was always on duty.

The houses were made of "dressed lumber sawed at the company's own mill." The homes were furnished and given free of charge. "The company also gives the illumination."

The article concluded by saying, "The concrete pouring begins on July 15." Just a few months later, Tugalo Dam was built.[201]

In Rabun County, a mountain lake sits on the border between South Carolina and Georgia. Lake Tugalo was created by Georgia Power when a concrete dam impounded the waters of the Chattooga and Tallulah Rivers. Land on the Georgia side is part of the Chattahoochee National Forest. The lake covers 597 acres, and you can see Lake Hartwell from its banks.

Note that Lake Tugalo is on the Tugaloo River, but the names of the two bodies of water are spelled differently. In the Cherokee language, *Tugalo* may mean "place at the forks of a stream."

The Most Ancient Town in These Parts

There was once a Native American town in the center of what is now Lake Tugalo. Tugaloo, the Cherokee town, is marked by a small island. The town was settled around AD 500. About 1450, the Cherokees moved in, and two hundred years later, Indian traders were coming to town. According to a marker on the banks of Lake Tugalo,

> *In 1716, while Col. Maurice Moore treated with Charity Hague, Cherokee Conjuror, a group of Creek ambassadors arrived. The Creek Indians, supported by Spain and France, wished to drive the British from the Carolinas in the Yamassee War. The Cherokees killed the Creek ambassadors and joined the British. By 1717, Col. Theophilus Hastings operated a trading center at Tugaloo where gunsmith, John Milbourne cared for Cherokee firearms. Indian agent George Chicken visited Tugaloo in 1725 and described it as "the most ancient town in these parts."*

Tugaloo, the Cherokee town, was destroyed by American Patriots in 1776 because of the natives' alliance with the British.[202]

Tugaloo Dam was the fourth large power development of the Georgia Railroad and Power Company. It provided work for one thousand men and increased power capacity by 43 percent in 1923. The project began in 1917 but was halted due to World War I. On January 1, 1922, the *Atlanta Constitution* reported that work resumed.[203]

The newspaper also warned the population about a huge explosion scheduled for May 1, 1923, and reported on it the day of: "Mountain Sliced at Tugalo Dam: Georgia Railway and Power Co. Gets Enough Rock to Finish Tugalo Dam." A great number of people watched the largest single blast the Southeast had seen (or heard).

> *The entire side of a mountain near the Tugalo dam, which is being built by the Georgia Railway and Power company, was completely and neatly sliced off this afternoon, when more than 50,000 pounds of TNT was discharged in one terrific blast. The earth quivered when the blast was set off, and more than 200,000 tons of rock tumbled down to the side of the Tugalo river.*

The noise could be heard for miles around, according to the newspaper. One minute before the blast, a five whistle warning was sounded. The cost of the blast was $50,000, and the displacement was enough to complete the dam.[204]

13

Lake Yonah

1925

In 1923, the *Atlanta Constitution* announced that names given by the Indians who once roamed the mountains, rivers, falls and valleys of Northeast Georgia were to be revived by the Georgia Railroad and Power Company. The company was using Native American monikers to name their water power–development projects. One area, Panther Creek, was changed to Yonah.[205]

In the Cherokee language, *Yonah* means "big black bear." Perhaps named for the population of black bears in the region, this reservoir, created in 1925 by the Yonah Dam, is at the end of the Georgia Power's string of great lakes. It follows the path of the ancient Tugaloo River, flows over the dam and continues to Lake Hartwell. The small, narrow lake has 9 miles of shoreline and 325 acres of water.

Yonah is the last link in Georgia Power's hydropower chain of lakes on the Tallulah River bed. Lake Burton is the first link, then Lake Seed is next, followed by Lake Rabun and the Chattooga River at Lake Tugaloo. The waters then flow through Hartwell's dams and continue to the Atlantic disguised as the mighty Savannah River.

The *Atlanta Constitution* romanticized the development in March 1925: "An immense power development in north Georgia's mountains by the G Railway & Power company, is a story as fascinating as any in the Indian lore, in which the section abounds—the story of struggles of managing against nature."

The article continued to tell the story from the beginning:

On Feb 13, 1913 "white coal," or water-power by wire began pouring over the company's transmission lines, because it was on that date that the first unit at Tallulah Falls was "brought in."

To get the water from the lake they had to drill a tunnel more than a mile long through the toughest rock imaginable. With nothing to guide them save the invisible eyes of the engineers' calculations, the drillers proceeded unerringly to the mark set out for them in the plans for the tunnel.

Workers completed the 56,000-foot-long Terrora Tunnel connecting Rabun Lake and Tallulah Lake on July 4, 1924. Then work on the Yonah development, located below the Tugalo plant on the Tugalo River, continued until the dam was built with 130,000 cubic feet of masonry. It took two years to build the dam and powerhouse. The Yonah development added immense power to the mountains and the cities and industries it helped build.[206]

In 1925 and 1926, Georgia suffered a drought, but despite water shortages, the power company's reservoirs, including Yonah, remained full and provided power to its people. When the drought eased, Georgia Railroad and Power company increased power hours from seventy-two to ninety-six hours because of the thirteen additional feet in Lake Burton that flowed down to Yonah. Power had been limited from 6:00 p.m. until 6:00 a.m. Despite the drought, Georgia Power was able to begin supplying power at 2:00 p.m.[207]

A SMALL ARMY OF TROUT

The *Atlanta Constitution* gleefully reported on April 28, 1927, that Lake Yonah and Nacoochee would have new residents. "Fifty thousand trout contained in a solid trainload of tank cars from government hatcheries in Erwin, Tennessee were released Wednesday in Lakes Yonah and Nacoochee in the North Georgia Mountains."

Rainbow trout has been a well-known commodity to Georgia anglers, but the Loch Leven variety has not. This "gamey" fish was first introduced to Georgia sportsmen at Lake Yonah.[208]

14

LAKE SEED

1927

Built between Burton Dam and Lake Rabun, Seed Lake takes advantage of a sixty-foot drop in the Tallulah River between the two lakes. Construction of the second lake on the Georgia Power series began in the summer of 1925 and was completed mid-1927. The 240-acre Seed Lake was created when the gates of Nacoochee Dam closed. *Nacoochee* comes from a Cherokee phrase meaning "evening star."[209] Building the dam was difficult for Georgia Railway and Power Company.

The Nacoochee Dam project was the last of the Georgia Power lakes in North Georgia and may have been the most difficult to build. The rugged mountains and wagon trails required the company to construct a temporary railroad. At first, to overcome this problem, materials were sent to the Lakemont rail station and then put on barges and transported nine miles up Lake Rabun.

The smallest of the Georgia Power lakes quickly became a residential lake. The earliest residents came just after the lake was at full pool. Summer cottages and log homes popped up in this remote area, but mountain traditions continued. Resident Howard McWhorter Jr. shared a Seed Lake secret: "The beauty of the lake and tranquility of the area were often interrupted by the production of corn liquor. One would see the gray whiff of smoke rise above the pines, and as the cooking vapor was turned back into a liquid, the loud banging and thumping barrel could be heard for miles."[210]

15

Lake Heath/Antioch

1995

Lake Heath and Antioch Lake in Floyd County were latecomers to the dam party. The project was not complete until 1988. Located in the Rocky Mountain Recreation and Public Fishing Area, these two lakes are a product of two power companies. The area has four lakes. Two lakes are operation pools closed to the public due to extreme water level fluctuations. The two open lakes serve as backup water storage for the generating system and do not fluctuate on a regular basis.[211] These human-made lakes are next to Berry College and its reservoir.

Berry College is the world's largest contiguous college campus. The Rome, Georgia private institution has more than twenty-seven thousand acres. Since the late 1970s, the campus is minus a few acres and an entire mountain. Georgia Power purchased Rock Mountain from the college. From the sky, the mountain resembled a bowl, making it a perfect location for a hydropower plant.

In 1985, Oglethorpe Power Corporation was looking for a location for a pump-storage hydroelectric plant. Georgia Power had stopped building Rocky Mountain at 20 percent. Georgia Power and Oglethorpe made a deal on December 15, 1988. The area is co-owned by Oglethorpe and Georgia Power at 75 percent and 25 percent. The Rocky Mountain Project recreational area is managed by the Georgia Department of Natural Resources, Wildlife Resources Division, and funded by Oglethorpe Power.[212]

PART III
THE TENNESSEE VALLEY AUTHORITY LAKES

THE TENNESSEE VALLEY AUTHORITY

The TVA will change your lives.

On May 18, 1933, President Franklin Delano Roosevelt signed the Tennessee Valley Authority Act. The mission of TVA was

> *to improve the navigability and to provide for the flood control of the Tennessee River; to provide for reforestation and the proper use of marginal lands in the Tennessee Valley; to provide for the agricultural and industrial development of said valley; to provide for the national defense by the creation of a corporation for the operation of Government properties at and near Muscle Shoals in the State of Alabama, and for other purposes.*

Two years after the Tennessee Valley Authority was created, Edward A. Woods wrote, "You of the Tennessee Valley region are living today as you are not going to be living twenty-five years hence. Your lives are going to be changed, first of all by electricity."[213]

Woods called the people in the land of cotton romantic but "enslaved by a brutal land economy."[214] C. Herman Pritchett justified the death of the rivers. He added to New Deal propaganda: "Congress created what was in many ways the most unique government agency ever set up in the USA."[215] TVA was not bound by state laws, jurisdictions or boundaries. The feds gave the TVA permission to build dams, promote navigation, control floods and generate power. Though not part of the original

purpose, soil conservation, new habitat development, mosquito treatment and hatcheries were positive byproducts.[216]

President Franklin Delano Roosevelt wanted a better life for the people of the region. Only three in one hundred had electricity, and few had running water. The raging flood-prone rivers only made life harder in the Tennessee Valley, which included the area of Blue Ridge and Towns County, Georgia. Crops were destroyed, and what the people did produce could not be sold because of poor river navigation.

In the 1930s, the South had not yet caught up with the North and was somewhere between reconstruction and restoration. Before the formation of the TVA, author Rupert Vance felt hydroelectric power development could "redefine the New South in relationship with the rest of the nation and improve the lives of Southerners."[217] He wrote how the water-saturated Southeast, especially North Georgia, "could be a force for change if they could harness the power of the wild rivers into electricity production."[218]

When World War II came, aluminum production in the Tennessee Valley increased. Power was needed for the plants, and Nottley and Chatuge became part of the war effort.[219] These projects were finished in record time to supply power for wartime production. Researcher Tom Bennett found some interesting facts in the National Archives in Atlanta. The anonymous engineering reports of the TVA recorded, "The four Hiwassee projects were operated initially for their best contribution to the World War II emergency."[220]

War propaganda, in the form of posters, was plastered around to get the public support and define this temporary function of the TVA reservoir projects. Even with all the positive spin, the Tennessee Valley Authority created controversy.

Edward A. Woods's prophesy came true. The TVA did change people's lives, for better and for worse. The displacement of towns and people caused hardship, and the environmental impact of dam construction was not considered the way it would be today. A "confidential report" in the files of the TVA in the National Archives revealed how the organization really felt about the people of the area, particularly Cherokee County, North Carolina farmers.

In the official records, a G. Donald Hudson and Malcom J. Proudfoot documented, "The area is characterized by a condition of social and economic maladjustment, which has reduced its agricultural production to a low-subsistence standard of living.…It is so low that the area as a whole

may be considered as sub-marginal and best fitted for afforestation or any practical use other than agriculture."[221]

Relocating the people was only a part of the problem; TVA had to move at least twenty-one cemeteries in the path of the Hiwassee Lake alone. Others were removed for Nottely and Chatuge.

The lives of North Georgians changed because of the TVA and its projects to bring power and flood control. Lives were changed and history erased.

17

LAKE BLUE RIDGE

1927

*So, I drove to the dam, it was a brand new Model T truck. I had to go way
down the hill. It was a new road. I had to work like the dickens to get out of
there. I had to back up and take a run up the hill.*
—*Charles Hoke Russell*

Charlie Hoke Russell grew up in rural North Georgia. His father,
Charlie Cleve, was a country doctor. Hoke would help his father with
his medical practice. His job was to always have his father's horse ready, fed
and watered and packed saddlebags full of medicine and medical supplies.
He first went on horseback, then a buggy and finally a Model T Ford.
His father would travel the North Georgia counties, delivering babies and
tending to the sick.

Hoke remembered, "He went all over the county, and the roads was bad.
He went out on calls in the middle of the night. Sometimes he'd be out all
night." Charlie Hoke took over the driving because his father did not know
how to back the car. He would go two miles out of his way just so he would
not have to put the car in reverse.

Hoke had three uncles who were also doctors, but he never followed in
their footsteps. Hoke did not go to medical school but traveled out west
during "Hoover Days" to hobo. He would hop trains and go out west to
places like Oklahoma and worked on a wheat farm for one dollar per day.

Hoke may never have made a doctor, but he enjoyed going with his father
on visits and coming back with stories. Charlie Hoke reminisced about his
father going to Carters Quarters in Murray County, where a community of
one hundred black families lived. (This area is now under Carters Lake.) Dr.
Russell doctored all of them. One cold day, Hoke went with his father inside

Charles Hoke Russell was one of the first to drive over the new Blue Ridge Dam. This is Hoke in 1927. *Courtesy of the Russell family.*

a home where a woman was about to give birth. Hoke remembered how the conversation went as he warmed himself by the fire,

"There was this woman just hollarin' and another woman started picking on her sayin, 'You ought to be quiet! If you had as many babies as I've had you'd know how to do!'"

Hoke continued, "Pa said, 'How many babies do you have, Ain?' and she said, 'Foteen.'"

During another delivery at Carters Quarters, the doctor needed to wash his hands. Charlie Hoke explained that the woman yelled at her husband to get some water for the doctor, but there was no response. Finally, she yelled, "What's a matter with ya man?"

The husband responded, "I was asleep!" The wife responded, "You were asleep nine months ago!"

Some of his tales were not humorous. One of Hoke's stories speaks to how far medicine has come. Hoke sadly told a story about one of those midnight rides.

"This woman give birth to a baby up there, they was twins. She couldn't hav e'em. Took a knife and cut 'em up and laid the baby arm on a newspaper an' a cat came along and carried it off."

Hoke and his father lived in Blue Ridge while the dam and powerhouse were being built. He claims he was one of the first people (beside the workers) to drive across Blue Ridge Dam:

> They were building dam over there and I worked for the Blue Ridge Grocery Wholesale House and the workers ordered canned good and hay and all kinds of stuff. So, I drove to the dam, it was a brand new Model T truck. I had to go way down the hill. It was a new road. I had to work like the dickens to get out of there. I had to back up and take a run up the hill.

Three men on the porch of a house. Summer camp of University of Georgia, Blue Ridge, Georgia, 1908. *Photo by Huron H. Smith, the Field Museum Library, CSB29576.*

Dinky train tracks used for dam construction in 1925 were exposed during a 2010 drawdown of Blue Ridge Dam. *Courtesy of Dr. Katherine Thompson.*

A 1925 stump left from the dam's construction in Blue Ridge Lake. *Courtesy of Dr. Katherine Thompson.*

Small-gauge, steam-powered dumping trains were placed on these single tracks to speed construction of Blue Ridge Dam. The 2010 drawdown exposed these tracks. *Courtesy of Dr. Katherine Thompson.*

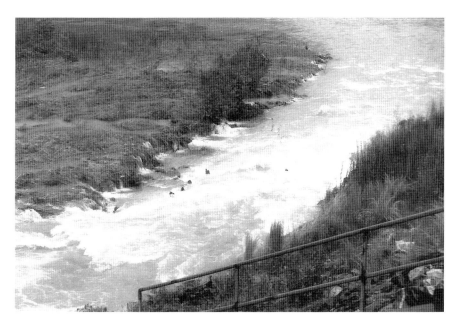

The Toccoa River stretches eleven miles southeast from the Blue Ridge Dam. The river flows northwest into Tennessee, where it meets the Oconee River. *Courtesy of Dr. Katherine Thompson.*

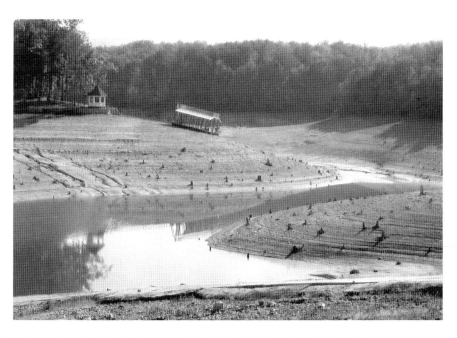

Blue Ridge Marina after the 2010 drawdown. *Courtesy of Dr. Katherine Thompson.*

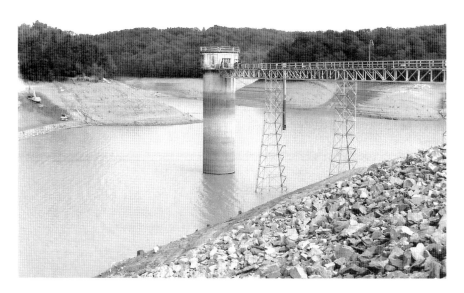

Drawdown intake station exposed at Lake Blue Ridge. *Courtesy of Dr. Katherine Thompson.*

Constructing the penstock for Blue Ridge Dam, August 7, 1926. *Courtesy of TVA.*

Blue Ridge Dam Power House control room, August 7, 1926. *Courtesy of TVA.*

Toccoa River view of Blue Ridge Dam, August 7, 1926. *Courtesy of TVA.*

Right: Blue Ridge Dam power station, 1926. *Courtesy of TVA.*

Below: Look south over future reservoir site, June 17, 1926. *Courtesy of TVA.*

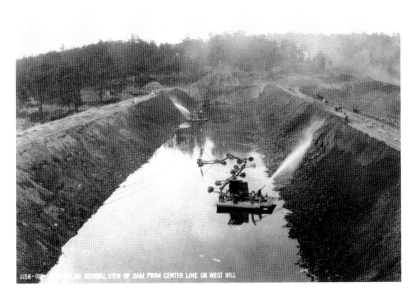

Washing away the dirt with a sluicing boat building Blue Ridge Dam, June 28, 1930. *Courtesy of TVA.*

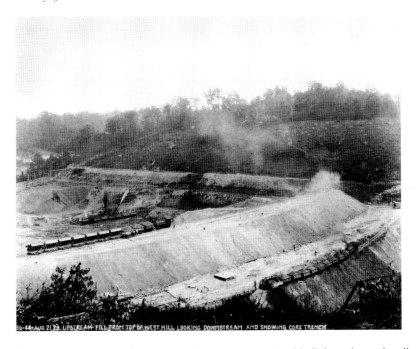

Toccoa Electric Power Company working on core trench with dinky train moving dirt and showing the core trench, August 21, 1929. *Courtesy of TVA.*

Penstock opening while building Blue Ridge Dam, August 7, 1926. *Courtesy of TVA.*

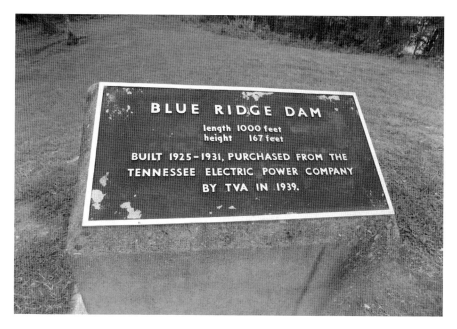

Blue Ridge Dam was built by Tennessee Electric Power Company beginning in 1925. *Author's collection.*

THE DRAWDOWN

When the lake was drained in 2010 to repair a crushed penstock under Blue Ridge Dam, it looked like a clear-cut forest. Reservoirs were prepared before World War II by cutting all the trees. After the war, the trees were left. The bed of Lake Blue Ridge looked like a desert. During preparation, the TVA cut the trees at the base. After eighty years, these stumps were preserved. Most wood decays, but the cold water and protection from insects petrified these stumps—it was an eerie sight.

Also seen during the 2010 draw down were artifacts from campsites, villages and farms. All the relics were protected under the Archaeological Resources Protection Act of 1979. How tempting it must have been to walk out on the dry lake and pick up some history. The government stopped this looting, and digging was left to the professionals. Items lost to amateur archaeologists leave holes in history. During the drawdown, people were not allowed on the lake bed; authorities were watching, and the fines were hefty. One of the places preserved, or at least pieces of it, is Fort Chastain.

"Drawdown Beach" on Lake Blue Ridge. Morgantown Beach at its lowest during the 2010 drawdown; the water level was approximately ninety feet below normal levels. *Courtesy of Dr. Katherine Thompson.*

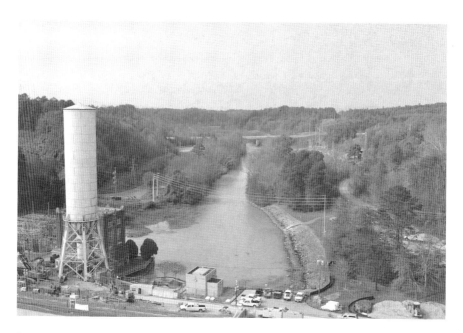

Standing on Blue Ridge Dam during 2008 repairs. *Courtesy of Dr. Katherine Thompson.*

Water releases at scheduled times each day accompanied by sirens and flashing lights. *Courtesy of Dr. Katherine Thompson.*

Beginning in 1925, the trees were cut for the impoundment. During the 2010 drawdown, a forest of petrified stumps was revealed. *Courtesy of Dr. Katherine Thompson.*

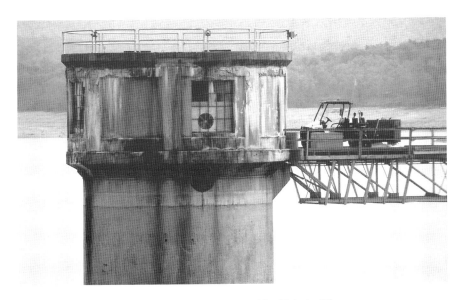

Close-up of the Blue Ridge intake, 2010. *Courtesy of Dr. Katherine Thompson.*

Fort Chastain and
What Lies Beneath Blue Ridge

During the government's takeover of Cherokee land, Native Americans were forced into one of the fourteen collection points. The collection sites were the beginning of the Trail of Tears. Under Lake Blue Ridge was one of these forts, Fort Chastain. Local historian Dr. Kathleen Thompson quoted a researcher, Ethelene Dyer Jones: "The Fort was near the convergence of Star Creek with the Toccoa River in what became Fannin County. Benjamin Chastain, who was sent as an Indian agent, opened the first post office in 1837." The fort was named for him, and he helped round up the Indians for the Trail of Tears.[222]

The TVA put out a press release on July 9, 2010: "Traces of campsites, villages and farmsteads remain even today and are considered archaeological resources containing important information about American prehistory and history. All remnants from any cultural period are protected under the Archaeological Resources Protection Act of 1979."[223] Fines were levied to treasure hunters in 2010–11 by the TVA. The organization was trying to protect Fort Chastain and other archaeological sites for future study.

Stacks

While the waters were low, a rock stack was recorded. Where the Toccoa River becomes Lake Blue Ridge, these rocks were exposed. They were not dumped but carefully stacked. Experts on Native American culture suggest that this pile is a marking for a Cherokee meeting place. The TVA will not comment.

Fort Nelson

In Morganton, five Confederate units were formed during the Civil War. Fort Nelson was set up near the Toccoa River close to the town. This area is now underwater near Morganton Point.[224] Children play on the beach in Morganton Point, and families camp along the banks. They might be interested to know that in the early 1860s, Rebels were inducted into the war and joined fighting units there.

THE UNDERWATER TRAIN

During an early drawdown, equipment for dam construction surfaced, and a TVA diver claims to have seen a train engine near the dam while doing repairs. In 2010, during the drawdown, the engine had disappeared. It is probably buried in sediment.

One thing that was not hidden were remnants of the dinky engine tracks. A dinky was a small-scale train used for hauling dirt and materials to and from construction sites. The tracks were close to the dam—even embedded in it. The remaining tracks cause sinkholes on the downstream side of the dam, but they have been repaired. Tracks were near the powerhouse, and one ran from the dam to the clay pit. The cars were loaded with dirt and dumped. As the dam rose, the track was reconstructed higher. During the 2010 drawdown, railroad spikes and even crossties were found.[225]

THE REALITY OF LAKE BLUE RIDGE

Lake Blue Ridge is comfortable. Many days while camping with my sons and husband, I sat under hardwood shade and watched my sons swim as little boys. Recently, we rented an overpriced canoe and kayak and paddled the coves. Well, I tried to paddle, and my son Michael secretly did all the work.

The 3,290-acre lake and surrounding area offer public swimming and picnic areas. Well-kept campsites are found at Morganton Point, and boat ramps abound. The lake itself is eleven miles long and has sixty-five miles of shoreline. Beautiful homes surround only 25 percent of the lake. The U.S. Forest Services manages the rest of the land, the Chattahoochee National Forest. The Fannin County Chamber of Commerce summarized the lake's history: "The lake was formed when Blue Ridge Dam was constructed on the Toccoa River in 1930 by the Toccoa Electric Power Company. At the time it was built, the dam was the largest earthen dam in the Southeast. The Tennessee Valley Authority (TVA) purchased the facility in 1939 for hydroelectric power production."[226]

The reality of Lake Blue Ridge is a contradiction. This special place stole my heart years ago, but now I look at it from a different perspective. I see the reality of human-made reservoirs. This peaceful place has pulled so many words and ideas that were drowning in my thoughts. The waters have saved my mind. When I need a day trip for rest, Blue Ridge is where I go. It is my

What lies beneath Lake Blue Ridge? *Author's collection.*

favorite lake in North Georgia. But I have also tubed down the enchanting Toccoa River, the same river that was cut in half by Blue Ridge Dam in 1930. The water is transforming.

The need for power and flood control was real, but I wonder how amazing that river would be today—flowing free, not interrupted by something contrived by engineers. One trip down the cool, no, cold Toccoa River on a hot Georgia day will change our life. The calm shoals and the rapid jaunts make for an afternoon adventure. Lake Blue Ridge and the Toccoa River have rehabilitated my busy mind for many years. I think there is a tube ride left in me.

18

LAKE CHATUGE

1942

The water sho' am lappin' at mah dooh—is you gwine to find me a home or is you isn't?

Chatuge Reservoir, located on the Hiwassee River in western North Carolina, is thirteen miles long and extends southeast from the dam into North Georgia. The reservoir is named after a nearby Cherokee settlement. Under the 150-foot-high Chatuge Dam lies an eighteenth-century Cherokee village. This land was Cherokee, and they settled along the rivers, so most of the lakes of North Georgia are hiding Cherokee settlements.[227]

Chatuge Dam was built to store water and reduce flood damage downstream, but it first operated for the war effort to strengthen flows at Hiwassee downstream. TVA engineers who designed the project said that "it is the story of the dependence of military preparedness upon aircraft, of aircraft upon aluminum, and of aluminum upon electric power."[228]

TVA is proud of its brand. "Chatuge Dam was built for the people, and the people feel a connection to it," said Mike Richards, TVA plant manager. "The dam gets a lot of public use, especially the walking path over the dam. The public is invested in the dam; they keep an eye out for it."[229]

BUILT FOR THE PEOPLE?

Imagine. You get a certified letter from the TVA offering you money for your land. And oh by the way, you have to sell or it will take it from you. In 1941, 278 families were forced to leave family homesteads. Some families had ancestors who came to the land in the 1840s as part of the Georgia Land Lottery. No amount of money would pay for ripping up roots. One relocated man said, "My connection to the land is lost. My heritage is gone."[230]

Eminent domain by the federal government sealed the deal for some families. Some were never paid. If you fought the government or were a tenant farmer, you lost. In addition to the families being removed, 540 graves were dug up and moved, and forty miles of roads were flooded.[231] The Elf School would be surrounded by water. About 283 students would be moving with their families just to get to school.

Not even their neighbors were hospitable. Nearby Hayesville grew during the construction of Chatuge Dam, and construction workers contributed to the economy of this North Carolina town. Relocated Georgians did not fare well in the real estate market. The people of Hayesville raised the price of land on those who needed it most—not so neighborly.

Hettie Anderson's porch and her grandchildren, Chatuge Reservoir, November 18, 1941. *Courtesy of National Archives, Atlanta.*

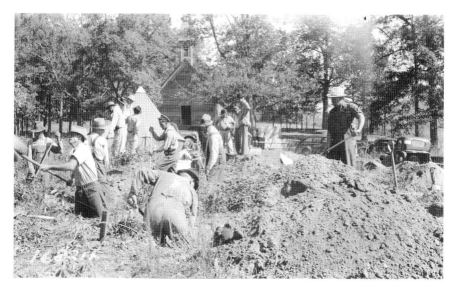

Ledford Chapel Cemetery disinterment operations for the Chatuge Reservoir, June 18, 1941. *Courtesy of National Archives, Atlanta.*

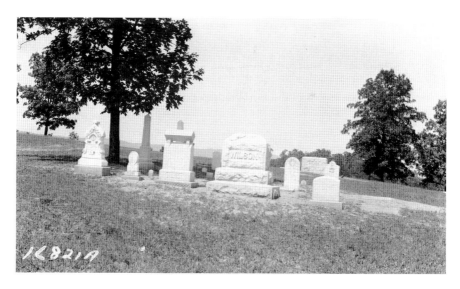

Wilson-Haley reinterment plot moved from Ledford Chapel Cemetery during Chatuge Reservoir Project, June 18, 1941. *Courtesy of National Archives, Atlanta.*

Grave Robbers

Wayne Nicholson was thirteen years old when men came to his Rabun County school and asked for volunteers. The men were looking for grave diggers. A busload of schoolboys went to the site where they were building Lake Chatuge. In 1946, they did not use backhoes but backbones of young men to dig up hundreds of graves. Nicholson said that it was hard work because the ground was hard.

Nicholson remembers, "It was a weird feeling digging up people's graves, especially when you got the boxes." Then the kids got out of the way, and the sheriff's department took over. Nicholson said, "At first, I was reluctant to do it, then you talked to your friends and said, 'why not?'" He continued that it was a different kind of life experience. "In the end, us kids enjoyed doing it."[232]

Civil engineer H. Jervy Kelly was in charge of cemetery relocations for the TVA during this period of building. He must have had unique traits to be selected for this project. He had to deal with families who were already upset with relocation. He published carefully drawn sketches of each plot that had to be moved. Then he contacted the state board of health to get permission to move the dead bodies and ran an ad in the newspapers. TVA established reinterment cemeteries.

This account was about Cherokee County, North Carolina, but the same process was used for North Georgia and Lake Chatuge. In the path of Chatuge, 20 cemeteries with 2,200 graves had to be moved. An unnamed engineer wrote: "After identifying all possible graves and determining the wishes of the nearest relative that could be located, it was found necessary to move 581 graves in five cemeteries. They were removed to eight re-interment cemeteries."[233] One question lingers unanswered: what happened to the other cemeteries and the other bodies?

The Whirlwind

The Chatuge project was a whirlwind. TVA employees worked twenty-four-hour shifts but took off on Sundays. The speed of construction created chaos. People were not getting offers and not moving. The evacuation deadline was December 1941. People were trying to find places to live, and some did not make the deadline. A local paper posted

on January 9, 1942, that some "old-fashioned neighborliness was needed to help people move." The land was torn up, and even wildlife ran away when their habitats were chewed up by heavy equipment. A lone chicken stood looking for a roosting place. The TVA was burning barns, destroying homes, cutting trees and clearing the land.

The rich bottom soil was washed away.[234] Soon, water would cover 3,700 acres in Towns County, Georgia. The dam and lake were named *Chatuge*; in Cherokee, this means, "the meeting of waters." Irony.

Top: Lonely house on a hillside identified as "Dwight ???" Chatuge Reservoir, January 27, 1945. *Courtesy of National Archives, Atlanta.*

Bottom: Identified as "Toilet Near House CHR-37," outhouse on future Chatuge Reservoir land, January 27, 1945. *Courtesy of National Archives, Atlanta.*

Was Lake Chatuge really *built for the people* as the slogan promised? People were convinced by the propaganda machine of the TVA that the dam was needed to win World War II. Posters in the National Archives read:

We are building this dam to make the power to roll the aluminum to build the planes to beat the bastards.

Out of water power. Comes air power…this is a TVA war job

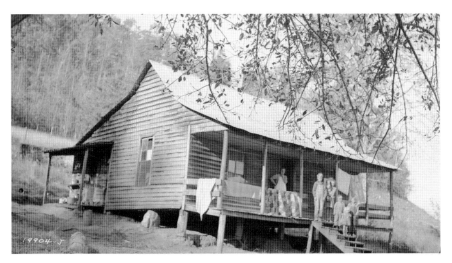

Top: A.J. Ferguson's home reclaimed for the Chatuge Reservoir, November 18, 1941. *Courtesy of National Archives, Atlanta.*

Bottom: View of the bottomland on the upper Hiwassee River, Chatuge Reservoir, July 3, 1941. *Courtesy of National Archives, Atlanta.*

TVA employee views the outhouse on the property. A chicken house is in the background. (CHR-14) Chatuge Reservoir, January 27, 1945. *Courtesy of National Archives, Atlanta.*

Smokehouse near a dwelling within the reclamation area for Chatuge Reservoir (CHR-14), January 27, 1945. *Courtesy of National Archives, Atlanta.*

Pigpen, shed, crib and barn on tract CHR-13, Chatuge Reservoir, January 27, 1945. *Courtesy of National Archives, Atlanta.*

Garage near the house on tract CHR-37, Chatuge Reservoir, January 27, 1945. *Courtesy of National Archives, Atlanta.*

Other propaganda included images of people working in the Aluminum Company of America (ALCOA) and the Tennessee Shoe Factory as testimony of their use of TVA electricity and the contribution of aluminum and shoes to the war effort.[235]

Feed mill and serving customers, January 9, 1942, Chatuge Reservoir. *Courtesy of National Archives, Atlanta.*

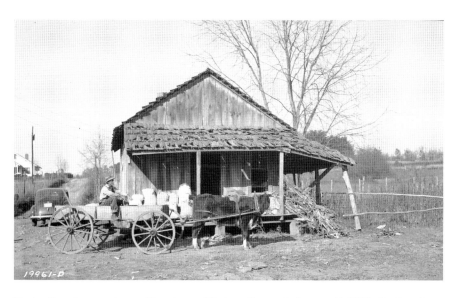

Feed mill and man using ox like a horse, Chatuge Reservoir, January 9, 1942. *Courtesy of National Archives, Atlanta.*

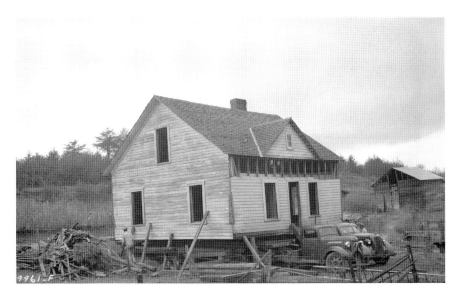

Moving day for Ray Sims, January 9, 1942, Chatuge Reservoir. *Courtesy of National Archives, Atlanta.*

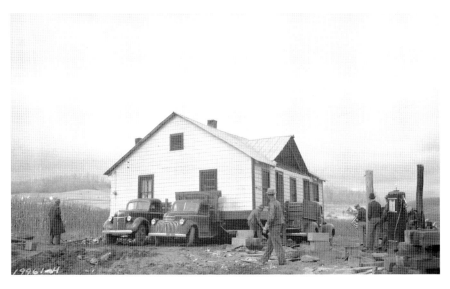

Two trucks are ready to move Clay Allen's House and Café, 1942, Chatuge Reservoir. *Courtesy of National Archives, Atlanta.*

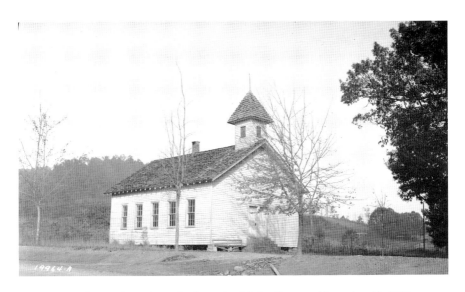

Woods Grove Baptist Church was in the path of Lake Chatuge, November 18, 1941. *Courtesy of National Archives, Atlanta.*

The Walter Ledford Residence and Store moving for the Chatuge Reservoir, November 18, 1941. *Courtesy of National Archives, Atlanta.*

Residents getting feed from the Garrett Barn, January 9, 1942. *Courtesy of National Archives, Atlanta.*

Paul Foster's Store lies on the bottom of Lake Chatuge. Notice the old Gulf sign, January 9, 1942. *Courtesy of National Archives, Atlanta.*

Are the People Better Off?

The area that became Chatuge Lake was a poor place. In 1880, farmers sold off the timber to northern timber companies. They clear-cut the land and did not add much to the local economy. The mountains were not productive for crop farming, so the families were subsistence farmers. They lived hand to mouth. The change began before the TVA decided to build the dam.

In 1937, the rural South was still recovering from the Depression. The Chattahoochee National Forest was sanctioned, and tourism was born. The impact was minimal at first, but a tourism-based economy grew. When TVA dammed the Hiawassee, it brought needed jobs to the area. Once the project was completed, there was a lake to increase tourism dollars. Events like the Georgia Mountain State Fair only added to the growth.

Thousands of acres were lost, and people had to move from their homesteads, but the lake brought an infusion to the local economy. The people had different views. A few were certain it was for the best. They thought they would have a better life by moving. Others who were used to subsistence living had difficulty transitioning to having to use money to live. Most had never seen as much money as TVA gave them; they were accustomed to feeding themselves on what they grew and bartering for what they needed.

Towns County Courthouse–Georgia is near the Chatuge Reservoir, 1942. *Courtesy of National Archives, Atlanta.*

The TVA had a readjustment program that was supposed to minimize any disruption resulting from dam construction, but one document noted: "The process of moving has been greatly speeded up on recent projects which are being constructed to furnish power or the war industries. On the Hiwassee project families were given only six months after the authorization of the projects."

The TVA authorities were not without heart. A ninety-year-old man was so ill he was not able to move. The closing of Chatuge Dam was delayed several weeks until his doctor agreed the he could move.

Chatuge is an earth-fill dam that is 144 feet high and 2,850 feet long. Work began July 17, 1941, and the dam was closed and the lake formed eight months later on February 12, 1942. It cost $9,504,000. In it, there are 2,347,400 cubic yards of earth and rock fill and 10,000 cubic yards of concrete.

Almost 3,700 acres in Towns County, Georgia, were flooded. Almost all of the 278 families were gone before the dam doors closed. However, months after the lake began to fill, 5 families refused to leave. They were then evicted by court order.

19

LAKE NOTTELY

1942

I'm agin dams of any kind.
—Ella Garth, Wild River

S omething about the 1960s B movie *Wild River*, starring Montgomery Cliff as a TVA officer, reminds me of what happened in Lake Nottely. This chapter's images of homesteads that would soon be flooded are haunting and real. The movie, set in the late 1930s, rang true, as Cliff, Chuck Glover, is trying to convince the only person who had not sold her land before the gates closed on the dam. The old woman, Mrs. Garth, owned an island in the middle of the river, and on the island's peak was the Garth family cemetery.

"Mrs. Garth, you're the only person who hasn't sold in this valley," Glover says.

"I don't care about the others," retorts Mrs. Garth. "Do you know anything about this land?"

"Yes, that is why the TVA sent me here," the TVA agent responds.

"Go down to the pontoon and pick up some soil—it's real bottomland," Garth instructs.

The TVA agent replies, "And thousands of tons of it are being washed away every year." He continues,

> Mrs. Garth, you don't—you don't love the land. You love your land. You
> know the Tennessee River has been a killer for years. Year after year, it's

taken God knows how many lives. Isn't it just plain common sense to want to harness it? And do you know what that will mean? Today, 98 percent of the people in this valley have no electricity. The dam will bring them electricity.

The old woman responds, "I expect that's what you call, uh, progress, isn't it?"

"And you don't?"

"No, sir, I don't. Takin' away people's souls. Puttin'—puttin' electricity in place of them. Ain't progress, not the way I see it.'

"It's not taking away their souls. We're giving them a chance to have a soul, and it isn't just this dam. Its dam after dam after dam. We aim to tame this whole river, " boasts the proud TVA man.

You do? Well, I like things runnin' wild like nature meant. There's already enough dams lockin' things up. Taming 'em. Making 'em go against their natural wants and needs. I'm agin dams of any kind....Oh, you, you can get me off by force, I reckon. It won't take much force. But it will take some. And that's the only way you'll ever get me off here, because I ain't a-going against nature. And I ain't a-crawlin' for no dang government.

The movie ends with a flyover atop the now submerged island. All that remains is the top of the cemetery where Mrs. Garth is laid to rest.

This Hollywood scene could have played out in the area that would become Lake Nottely. The images in this chapter came from the National Archives in Atlanta. As they were buried in cold storage, my son Samuel carefully pulled the old negatives and scanned ghostly scenes not seen for years. Perhaps you will see a Mrs. Garth in these photos.

The strangest images are men digging up graves. In the path of Nottely Lake, there were eight cemeteries with eighty-six graves. One report stated, "Three small cemeteries were below elevation 1,785, five feet above the top of the spillway flashboard. After all possible grave identifications had been made and the next of kin had been contacted, it developed that only two removals would be required."

On the edge of North Carolina, the Nottely River was named for the Cherokee village of Naduhli. The village along the river was named for "daring horseman." The heavily wooded area of mountains and valleys surrounding the upper Nottely River was eyed by power companies in the 1930s. Then the TVA, shortly after its creation, looked to Nottely for

Mr. and Mrs. C.L. Mason in front of their home, lost to the Nottely Reservoir, September 30, 1941. *Courtesy of National Archives, Atlanta.*

C.L. Mason and his wife walk up the hill on the side of their homestead, claimed by TVA for the Nottely Reservoir project, September 30, 1941. *Courtesy of National Archives, Atlanta.*

flood control in Chattanooga, Tennessee. The dam was not authorized for electricity production. But that would soon change.

Construction began in 1941. Then World War II created an emergency demand for electricity to power the aluminum plants in East Tennessee. Nottely Dam was authorized because it could push water downstream to the power-producing Hiwassee Dam. Writer Tom Bennett researched the war connection and made this conclusion:

> *Until the threat of a world war loomed on the horizon, the 1936 Hiwassee Dam's turbines turned with the clear purpose of achieving TVA's lofty goals of that first decade. These were to provide jobs and turn on the lights, generating electricity to improve the lives of the people while also preventing flooding downstream.*
>
> *However, I came to believe this isn't true for the 1941–43 Nottely, Chatuge and Appalachia dams. The actual records of the engineers themselves describe how those three were built in a hurry to store more water for Hiwassee Dam. Nottely and Chatuge took only about eight months, Appalachia, which is cement concrete like Hiwassee, took longer.*
>
> *Together these dams joined a giant system making power to help the U.S. defeat the Axis powers of Germany, Japan and Italy in the World War then starting up in Europe. Soon it would be formally entered by the U.S., after the attack on Pearl Harbor on Dec. 7, 1941. Specifically, TVA power helped make warplanes, conventional munitions and the atomic bomb.*[236]

Nottely near Ivylog cableway, right bank, 1939. *Courtesy of National Archives, Atlanta.*

Nottely River near Ivylog measuring section, upstream from Right Bank, Ivylog, Nottely Reservoir, February 11, 1939. *Courtesy of National Archives, Atlanta.*

Nottely Quarry during the building of Nottely Reservoir, May 18, 1944. *Courtesy of National Archives, Atlanta.*

The TVA bought eight thousand acres, relocated ninety-one families and redesigned twenty-one miles of roads.

Workmen built a simple dam. They formed the dam by building a rock and stone crib and filling the middle with earthen fill. The project was completed quickly. The gates were closed in January 1942.

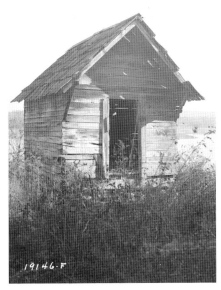

Left: Smokehouse NLR 24, Nottely Reservoir, November 13, 1942. *Courtesy of National Archives, Atlanta.*

Below: Chicken House NLR-24, Nottely Reservoir. *Courtesy of National Archives, Atlanta.*

Opposite, top: Nottely Dam construction site looking south, April 15, 1941. *Courtesy of National Archives, Atlanta.*

Opposite, middle: Period car drives on the Nottely ground water wells at Nottely Reservoir, April 25, 1941. *Courtesy of National Archives, Atlanta.*

Opposite, bottom: Nottely River below Nottely Dam looking downstream. Dam is nearing completion, June 25, 1942. *Courtesy of National Archives, Atlanta.*

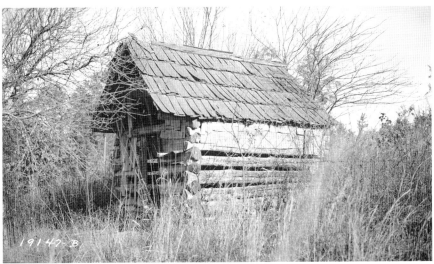

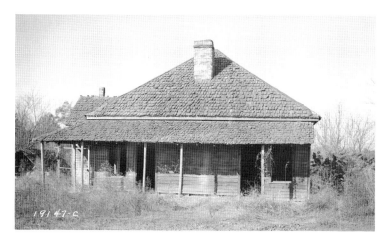

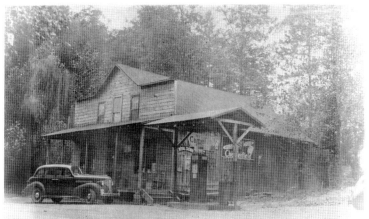

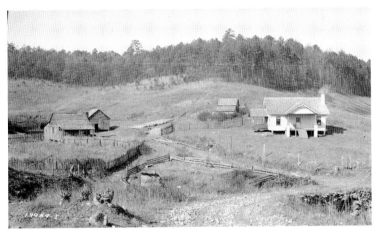

Above, top: William Plott's residence, November 24, 1941, Nottely Reservoir. *Courtesy of National Archives, Atlanta.*

Above, bottom: Paul Nicholson's home and buildings were destroyed during the construction of Nottely Reservoir, November 24, 1941. *Courtesy of National Archives, Atlanta.*

Opposite, top: Dwelling NLR-24, Nottely Reservoir. *Courtesy of National Archives, Atlanta.*

Opposite, middle: A.M. McAfee Store was destroyed for the Nottely Reservoir, October 7, 1941. *Courtesy of National Archives, Atlanta.*

Opposite, bottom: Ben Teague heirs' house in Union County. Nottely Reservoir, November 24, 1941. *Courtesy of National Archives, Atlanta.*

Charles Brewer family, Nottely Reservoir, December 29, 1941. *Courtesy of National Archives, Atlanta.*

The Birdie Young home place, December 29, 1941. *Courtesy of National Archives, Atlanta.*

Left: Empty storehouse (NLR-24), photographed by TVA for reclamation, Nottely Reservoir Project, October 8, 1942. *Courtesy of National Archives, Atlanta.*

Below: Lonely homestead on a hillside (NLR-121), now under the Nottely Reservoir, October 8, 1942. *Courtesy of National Archives, Atlanta.*

Top, left: Smokehouse (NLR-121), now part of Nottely Reservoir, October 8, 1942. *Courtesy of National Archives, Atlanta.*

Top, right: Union County Georgia Courthouse, Blairsville, near the Nottely Reservoir, June 26, 1941. *Courtesy of National Archives, Atlanta.*

Bottom: Dilapidated dwelling (NLR-69), now part of Nottely Reservoir, October 8, 1942. *Courtesy of National Archives, Atlanta.*

The Union County Georgia Courthouse is still standing and is home to the Union County Historical Society and Museum. *Courtesy of National Archives, Atlanta.*

Lance Mill at Moccasin Creek, now part of the Nottely Reservoir, July 14, 1941. *Courtesy of National Archives, Atlanta.*

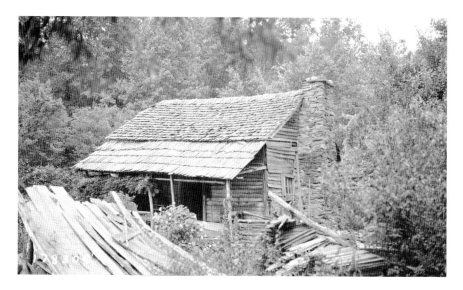

Brad Brackett home on Nottely Reservoir Project land, June 26, 1941. *Courtesy of National Archives, Atlanta.*

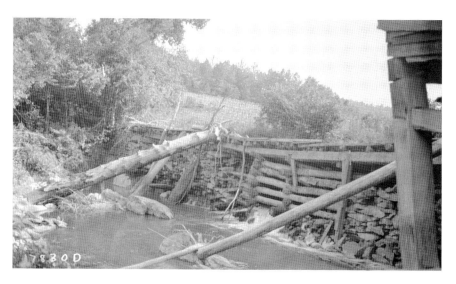

Dam at Davenport Mill on Nottely Reservoir reclamation land, June 26, 1941. *Courtesy of National Archives, Atlanta.*

Smith's Sawmill contract to support the Nottely Reservoir project with a truckload of logs to be sawed, November 29, 1941. *Courtesy of National Archives, Atlanta.*

Logs ramped or yarded at the Smith Sawmill, Nottely Reservoir, November 29, 1941. *Courtesy of National Archives, Atlanta.*

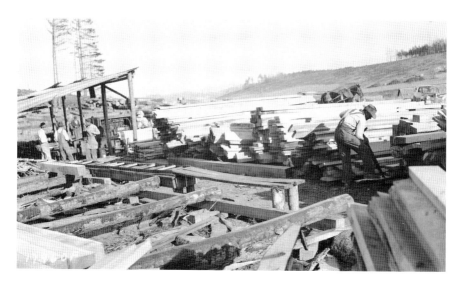

Lumber stacked on the yard ready for delivery to Nottely project, November 29, 1941. *Courtesy of National Archives, Atlanta.*

CONFIDENCE SCHOOL AND PROVIDENCE SCHOOL

A Google Maps search near Lake Nottely reveals communities, churches and references to historical schools. The TVA documented two historical schools moved during relocation. Images frozen in time show the old Providence and Confidence Schools and the new ones being built. Images found in the National Archives are rare and were taken in the fall of 1941.

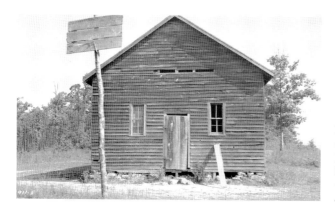

Front view of the Confidence School, Nottely Reservoir, September 30, 1941. *Courtesy of National Archives, Atlanta.*

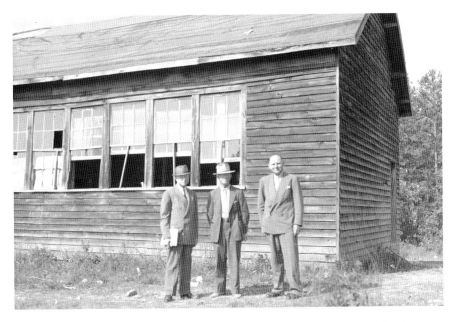

Unidentified officials on the side of the Confidence School, reclaimed for the Nottely project, September 30, 1941. *Courtesy of National Archives, Atlanta.*

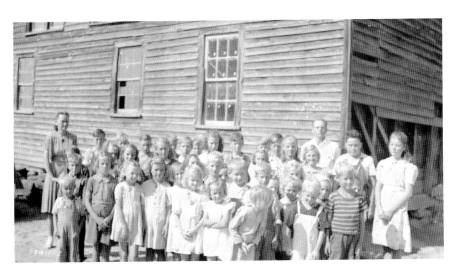

Schoolchildren in front of the Providence School, Nottely Reservoir, September 30, 1941. *Courtesy of National Archives, Atlanta.*

Based on the man on the ladder painting, this may be the new building Providence School moved to once the waters of the Nottely Reservoir covered their old school, September 30, 1941. *Courtesy of National Archives, Atlanta.*

EXPLORE

Rumor has it that if you have scuba gear, you can find the remains of a town that was flooded when the TVA created Lake Nottely. Like most of the lakes of North Georgia, nothing remains under the water except old fishing line and trash. During the lake's low point from October to April, you can hike along the shore and find interesting artifacts. Be careful—all lakes are protected from relic hunters, and steep fines will be accessed.[237]

Also, like most of the North Georgia lakes, the land was originally Cherokee or Creek. It is not a far stretch to assume there were Cherokee villages along the Nottely River, which was forded for the dam.

Lake Nottely is undeveloped and protected by the U.S. Forest Service. Some 70 percent of Nottely's shoreline protects almost half of Union County from development. It is just a few miles north of Blairsville, Georgia. The lake has cliffs for swimmers to jump and plunge into the cool mountain lake.

THE HAUNTING QUESTION,
"WHAT IF?"

Anyone who wants to experience the way Georgia was when God made it…can
go to the upper parts of the Flint River.
—President Jimmy Carter

What if?" is a disquieting question. Wondering what might have been feels like magical thinking. Yet Oliver Wendell Holmes guides us: "To understand what is happening today or what will happen in the future, I look back." President Jimmy Carter looked back when Georgians were trying to preserve the Flint River in its natural state. He canoed down the Chattahoochee and the Chattooga Rivers, and when he was in a place to stop construction of another dam, he changed the future.

In an article for *Brown's Guide*, Carter remembered:

> *As a boy growing up in Archery, I worked fields that drained into Choctahatchee (or as we called it, Chock-li-hatchet) Creek. Choctawhatchee Creek joins Kinchafoonee Creek, which merges with Muckalee Creek and flows into the Flint River just above Albany. The Choctahatchee was where I fished. It was where I learned about the out-of-doors, where I learned to explore, and where I learned how not to get lost. It's where my playmates and I, and occasionally my father, had many hours and days together. We had an immersion in the natural world that has marked my whole existence.*[238]

Carter had to deal with natural resources as a state senator and was a founder of the Georgia Conservancy. He said, "It was a part of my attitude when I became governor."[239] As an advocate for the protection of the Chattahoochee River in the Atlanta area, he created the Georgia Heritage Trust. Carter fought a few losing environmental battles, but the Flint River was different. He wrote:

> There was a period of time during the economic evolution of our state's and our nation's history, when it was inevitable that many of our dams would be built and naturally free-flowing streams would be obstructed. The primary reason for these dams was power production, and in some areas, flood control. Later, to some degree, recreation became a justification.[240]

The former Georgia governor remembered a time when congressmen aligned with the USACE. Southern Democrats pushed hard for dams to be built in their districts with hopes of it being named for them. He said, "One of a Congressman's highest goals in life was to have built in his district a notable dam at federal government expense that would create a lake that could be named for him."[241] An unhealthy relationship developed between Congress and the Corps. On paper, the Corps justified the cost versus the benefits of building a dam to please the lawmakers who supervised it. Carter said, "So there were hundreds and hundreds of dams being built around the country over a 10-year period. Almost all of them were unnecessary, yet, at the same time, they were quite attractive to the local communities involved as presented in the economic benefits analysis prepared by the Corps."[242] The Flint River Dam at Sprewell Bluff was to be one of those projects.

The Flint is the longest-remaining free-flowing major river in Georgia. It flows 344 miles and exposes its travelers to a wide variety of vistas. But this was almost not the case. The Flint could have been dammed. Congressman Jack Flint wanted the dam in his district near Thomaston.

As governor and an environmentalist who had learned to roll a canoe in the Georgia State University swimming pool, Carter went down the Flint. He was urged by fishermen, outdoorsmen and others to look at the proposed dam project on Flint River to see if there was justification.

Governor Carter made a commitment that was time-consuming and unpleasant, meeting with everyone involved. He found the primary justification was for recreation. It would be good for business in the area during the construction, but the sportsmen groups raised contrary views.

Carter noted a time when environmentalists and sportsmen groups were small and not vocal. Times had changed.

Georgia congressman Jack Flint was indignant at the investigation. Carter examined the facts and figures from the USACE. The Corps is part of the military, and Carter had no reason to doubt the data. But as he looked deeper, "I found that sometimes—if there was a question about economic benefits of the Sprewell Bluff project—they would triple the alleged benefits with no substantiating data to back up the change."[243] The Corps kept saying there was a need for another "broad water lake," but within fifty miles of the Sprewell Bluff there were more than a half dozen that never reached the potential economic benefits projected by the Corps.

Carter stated,

> *If anybody wanted to go back and look at the Corps of Engineers analysis of benefits that would accrue in tourism, they would find that those benefits are just a complete passel of lies and exaggerations to justify a project the Corps wanted to construct and that a member of Congress wanted to have constructed. It would give the Corps work to do and justify its existence, and they thought nobody would question it.*[244]

Then there was the flooding myth.

The USACE brought up flood control. Carter discovered the Corps had exaggerated the facts: "The only way you can control flooding with a dam of this kind, I learned at the time, is to reduce the water level in the lake by 10 feet in anticipation of heavy rains so that when the rains fall, instead of running downstream, the rain would fill up the lake. Well, you can't anticipate that." Even the USACE's own data showed that a Sprewell Bluff dam on the Flint would have little effect below Lakes Blackshear and Chehaw.

On October 1, 1974, Governor Jimmy Carter decided that the flood project would be vetoed. This raised protests from the chambers of commerce and Congressman Flint's supporters.

When Carter became president, he did not forget the Flint River project. He examined all the U.S. Army Corps of Engineers projects in all fifty states. He questioned dam projects that were not being questioned. He began to veto projects. He had the law changed so that a project like at Sprewell Bluff would have to be partially funded locally. Before, these projects had 100 percent federal funding. The Flint River project at Sprewell Bluff helped change the national attitude toward dams and slowed or stopped ill-advised projects:

I think it has been worth all the confrontations and the debates and sometimes disharmonies that have resulted from what is still an ongoing process in America of preserving things instead of trying to modify them in an unnecessary fashion.
—*President Jimmy Carter, on saving the upper Flint from being dammed in the 1970s*

Years later, the people who cursed Carter for vetoing that dam in Thomaston are grateful to him. They are happy to have their river. Carter concluded,

Anyone who wants to experience the way Georgia was when God made it or the way it was when it was first settled by white people can go to the upper parts of the Flint River and see how beautiful it is. It is breathtaking in its beauty. And the wildlife that exist in that river corridor: otter, fox, muskrat, beaver, bobcat....You cannot describe it. It is a treasure. A treasure that is appreciated by an increasing number of people as the generations pass.[245]

If the natural rivers were left alone by the politicians, power companies and the Corps, we would have wild-running, beautiful, natural waters in North Georgia. The Flint River is our example from the past and for the future.

A CHANGE OF HEART

Carter challenged the status quo and stopped the unnecessary damming of our natural rivers. In the process of writing this book, my heart has changed.

Before researching the North Georgia lakes for this book, I have never fought for the environment. It is funny how when you spend time engaging with our culture and our natural environment you look at things differently. I drive across, by and near Lake Allatoona almost every day. Over the last forty years living in North Georgia, I never looked so hard into the depths of the lakes that surround me. I thought this was just going to be about the lost and drowned towns, what lies beneath the surface of the human-made lakes. It was so much more. As I gazed deeply into the unnatural lakes, something began to haunt me. It haunts me still.

The word *haunt* has a curious etymology. In Middle English, it means to frequent a place. The Germanic origin suggests a meaning of being

"distantly related to home." I kept returning to these lakes, longing for the lost rivers. I asked, sometimes out loud, as I walked the banks of the lakes, "What if?" What if the rivers were left alone? What if someone fought for you to stay natural? The lakes feel like intruders. The rivers feel like home.

How many homes were lost during this progress of midcentury North Georgia? Some say ghosts return when their spirits are restless, and if a home has changed or been demolished, it stirs the night with haints. What ghosts haunt the lakes of North Georgia? Are the submerged societies full of restless spirits?

Do Native American souls return to a home that is five hundred feet below the water at Carters Lake? Do the Abernathys visit to find their town has slipped off the bank near Macedonia Cemetery? Maybe Mark Anthony Cooper, the Ironman of Georgia and founder of the submerged Etowah, returns to find his beloved Glen Holly gone, as well as his family cemetery. Does he find them at Oak Hill Cemetery in town? Do Confederate soldiers return to the Battle of Allatoona Pass, fight again and then ride the phantom train?

Blue Ridge Lake. *Author's collection.*

Some feel that the most celebrated lake is cursed. Lake Lanier breeds many stories, but some stories are true tragedies. While most lakes have drownings, Lanier has odd occurrences that perpetuate the lore.

Maybe an Appalachian family returns to find their legacy, their land in the mountains of Rabun County impounded by one of Georgia Power Company's Great Lakes of North Georgia. And standing on Blue Ridge dam, I sensed my grandfather-in-law Paw-Paw Charlie Russell. I visualize him sitting in the old truck he drove over the dam under construction.

Imagine the Indians who settled the North Carolina border haunting their hallowed ground and finding gallons of water forming the unnatural lakes of Chatuge and Nottely. I wonder if this unsettles their spirits.

I keep returning to the question that discomfits me: What if we had left it alone? We cannot forget the past and pretend our missteps never happened. We must look hard and see connections. Connections are like the rivers that once snaked and flowed freely in North Georgia. They had purpose and power before they were cut in half. The New South required cheap hydroelectric power, and many places like Rome were saved from disabling floods. But now we can see the connections and ask questions. New solutions ensure that we will never have another underwater ghost town in North Georgia.

At the conclusion of the documentary *Flint*, a river lover said:

> *Just like any wild thing. As you get closer to it, it moves away. It does not want to get caught. It doesn't want to get dissected. There is a certain amount of mystery, you need to leave intact.*[246]

Notes

Preface

1. Bartram, *Travels of William Bartram*, 159.
2. McPhee, "Travels in Georgia," 191–92.
3. Ibid., 193.
4. Ibid, 192.
5. Carter, "Flint River Integrity."
6. McPhee, "Travels in Georgia," 170.
7. Ibid., 180.
8. Ibid.
9. Woodall, "Deliverance Stigma."
10. Ibid.
11. Martin, "Earthly Evidence."
12. Ibid.
13. Ibid.
14. Ibid.

Acknowledgements

15. Ballenger, *Curious Researcher*.

Land before the Lakes

16. Coulter, *Old Petersburg*, 2–3n2.
17. "Reservoirs in Georgia," http://southeastaquatics.net/resources/pdfs/reservoirs%20in%20georgia.pdf.

18. Ibid.
19. Manganiello, *Southern Water*, 131.
20. "Reservoirs in Georgia."
21. Ibid.
22. Ibid.
23. Ibid.
24. Ibid.
25. Ibid.
26. Manganiello, *Southern Water*, 38.
27. Muir, "Through the River," http://vault.sierraclub.org/john_muir_exhibit/writings/a_thousand_mile_walk_to_the_gulf/chapter_3.aspx.
28. Ibid.

Chapter 1

29. Bailey et al., "History of the South Atlantic."
30. Manganiello, *Southern Water*, 67.
31. Bailey et al., "History of the South Atlantic."
32. Ibid.
33. Ibid., 108.
34. Ibid.
35. Ibid.

Chapter 2

36. "In the Old Times," *Cartersville News*, March 16, 1905.
37. "Rev. Bard Abernathy," *Cartersville News*, March 31, 1910.
38. "EVHS Map Gallery," Etowah Valley Historical Society.
39. Russell, *Lost Towns*, 160.
40. "Ghost of Allatoona Pass," Explore Southern History, http://www.exploresouthernhistory.com/allatoonaghost.html.
41. Conine, "Brenda Landers Conine," https://www.facebook.com/groups/97177545592/permalink/10157003794530593.
42. Head, "Civil War in Bartow County," http://evhsonline.org/archives/44481.
43. Ibid.
44. Allmon, "Desperate Battle of Allatoona Pass," http://warfarehistorynetwork.com/daily/civil-war/the-desperate-battle-of-allatoona-pass.
45. Ibid.
46. Ibid.
47. Ibid.
48. Golden, "Battle of Allatoona Pass," http://www.ourgeorgiahistory.com/wars/Civil_War/allatoonapass.html.
49. Allmon, "Desperate Battle of Allatoona Pass."
50. Golden, "Battle of Allatoona Pass."

51. "Allatoona Pass," About North Georgia, http://www.aboutnorthgeorgia.com/ang/Allatoona_Pass.

52. Golden, "Battle of Allatoona Pass."

53. "Hero of Allatoona," *New York Times*, April 26, 1896.

54. "From a Private's Diary," *New York Times*, August 9, 1893.

55. Ibid.

56. Mooney, "Clayton-Mooney House."

57. Ibid.

58. Gregory, *Archival and Field Survey*.

59. Ibid.

60. Ibid.

61. Ibid.

62. See Russell, *Lost Towns of North Georgia*, for more about the lost town of Auraria, Georgia, and the first gold rush.

63. Gregory, *Archival and Field Survey*, 44.

64. Ibid., 48.

65. Ibid.

66 "Sixes Gold Mine Has Rich Ore," *Atlanta Constitution*, September 23, 1897, 9.

67 Goff, Utley and Hemperley, "No. 52 Sixes," 143.

68. Vogt, "Lovingood's Bridge."

69. Gregory, *Archival and Field Survey*, 48

70. Cox, "Farmers Migrating En Masse," 4.

71. Ibid.

72. Sibley, "Etowah Valley."

73. Ibid.

74. Ibid.

75. "Why Lake Allatoona Is Still Flooded," http://www.lake-allatoona.com/blog/why-lake-allatoona-is-still-flooded; Battey, "Did You Know?."

76. Ibid., 469.

77. Ibid., 303.

Chapter 3

78. Sibbald, *Notes and Observations*, 6263.

79. Longstreet, "XV," 129.

80. Elliott, "Pulse of Petersburg."

81. Ibid.

82. Ibid.

83. Ibid.

84. Coulter, *Old Petersburg*.

85. Ibid.

86. Ibid.

87. Ibid.

88. Ibid., 106.

89. Ibid., 109.
90. Ibid., 111.
91. Ibid., 145.
92. Ibid., 165.
93. Ibid., 166.
94. Ibid., 168.
95. Ouzts, "Petersburg."
96. Coulter, *Old Petersburg*, 172.
97. Ibid.
98. Ibid., 173.
99. Elliott, "Pulse of Petersburg," 67–71.
100. Pavey, "Drought-Lowered Reservoir."
101. Pavey, "Falling Water."
102. Pavey, "Drought-Lowered Reservoir."
103. The official name is J. Strom Thurmond Dam and Lake at Clarks Hill. There have been issues with the name. Congress initially authorized this dam, "Clark Hill Dam," but the name was wrong. Due to a clerical error, the "s" was left off. Senator J. Strom Thurmond asked that the dam be renamed "Clarks Hill." In 1988, the name was congressionally changed to "J. Strom Thurmond Dam and Lake at Clarks Hill."
104. Barber, "History of the Savannah District," 419–34.

Chapter 4

105. "Inflation Calculator," Saving.org Resources and Calculators, accessed August 13, 2017, https://www.saving.org/inflation.
106. Coughlin, *Lake Sidney Lanier*, 59.
107. "Engineers Buy First Buford Lake Area Land," *Daily Times*, April 14, 1954, 1.
108. Coughlin, *Lake Sidney Lanier*, 60.
109. Ibid.
110. Ibid., 214.
111. Ibid.
112. Ibid., 216.
113. Ibid., 217–19.
114. Ibid., 226.
115. Ibid., 228–30.
116. "Lost Race Tracks," https://www.jalopyjournal.com/forum/threads/lost-race-tracks.449335/page-2.
117. Bishop, "Relocating Vann's Tavern."
118. Estep, "Just How Deadly Is Lake Lanier?."
119. WGCL Digital Team, "Is Lake Lanier Haunted?."
120. Lavender, "View of History."
121. Ibid.
122. Ibid.

Chapter 5

123. U.S. Army Corps of Engineers, Savannah District [hereafter USACE], "Savannah District Hartwell Dam and Lake History."
124. $6,850.00 in 1956 had the same buying power as $61,709.30 in 2017 according to www.dollartimes.com.
125. USACE, "Savannah District Hartwell Dam and Lake History."
126. USACE, "Savannah District Hartwell Dam and Lake Introduction."
127. World Fishing Network, "Five Interesting Facts About Lake Hartwell."
128. USACE, "Savannah District Hartwell Dam and Lake History."
129. Scott, "Nancy Hart," 33.
130. Ibid., 35.
131. Hall, "Hart, Nancy Morgan."
132. Ibid.
133. Tiger Pregame Show, "December 31st Clemson Historic Picture of the Day."

Chapter 6

134. Dickey, *Summer of Deliverance*, 162.
135. Roper, "River Ran Through It," 20.
136. Ibid.
137. Ibid.
138. Ibid.
139. Ibid.
140. Ibid., 22.
141. Ibid.
142. Ibid.
143. Langford, "Post-DeSoto Apocalypse in Northwest Georgia."
144. Roper, "River Ran Through It," 20.
145. Ibid.
146. Ibid.
147. Farber, "'Deliverance', How It Delivers."
148. Ibid.
149. Roper, "River Ran Through It," 22.
150. Ibid.
151. Georgia River Network, "River Stories."

Chapter 7

152. Tennessee Valley Authority [hereafter TVA], "Richard B. Russell Dam and Lake," 78.
153. Ibid., 9.
154. USACE, "Pumpback and Its Effects."

155. Ibid.
156. Ibid.

Chapter 8

157. Mountain View Group, "Big Bets."
158. Manganiello, *Southern Water*, 61.
159. Calhoon, "Georgia Power Company."
160. Ibid.
161. Manganiello, *Southern Water*, 27.

Chapter 9

162. McCallister, "Tallulah Falls and Gorge."
163. Stephens County, Georgia, "History."
164. Ibid.
165. Coulter, *Georgia Waters*, 45.
166. Ibid., 46.
167. Ibid.
168. Ibid., 47.
169. Ibid.
170. "James Longstreet," Civil War Trust.
171. Learn more about Rebecca Latimer Felton, the first female U.S. senator and Georgia's first and only U.S. senator (at the time of this writing). Learn about her "Dress" at http://evhsonline.org/archives/44716.
172. Gardner, "Helen Dortch Longstreet."
173. "Tallulah Gorge State Park," About North Georgia.

Chapter 10

174. "Lake Rabun, History," Lake Rabun.
175. "Rabun County Historical Society," 2018, http://www.rabunhistory.org/photo-gallery/lakes-and-dams/?page=3.
176. Ibid.
177. Williams, "Summers on the Lake."
178. Ibid.

Chapter 11

179. Reynolds and Walker, "Folklore," 163.
180. Ibid., 173–75.
181. Coulter, *Georgia Waters*, 45.

182. "History," Rabun County Chamber of Commerce.

183. Brown, Jones and Perrie, *Georgia Conservancy's Guide*, 154–55.

184. "History," Rabun County Chamber of Commerce.

185. Ibid.

186. Reynolds and Walker, "Burton," 167–68.

187. Ibid.

188. Reynolds and Walker, "Burton," 164.

189. Ibid., 169.

190. "Inflation Calculator," accessed August 13, 2017, https://www.saving.org/inflation.

191. Reynolds and Walker, "Burton," 170.

192. "History," Rabun County Chamber of Commerce.

193. Reynolds and Walker, "Burton," 175.

194. Poss, "History of Lake Burton."

195. Reynolds and Walker, "Folklore," 202.

196. Ibid.

197. "North Georgia Lakes | Lakes & Recreation | Georgia Power," Georgia Power.

198. "Lake Burton | LBCA," Lake Burton Civic Association.

199. Ibid.

200. Russell, *Lost Towns of North Georgia*, 171–75.

Chapter 12

201. "Town Is Built to House Labor at Tugalo Dam," *Atlanta Constitution*, July 6, 1922, 16.

202. "Old Tugaloo Town," Colonial America.

203. "To Resume Work on Tugaloo Dam in North Georgia," *Atlanta Constitution*, January 1, 1922, 1.

204. "Mountain Sliced at Tugalo Dam," *Atlanta Constitution*, May 2, 1923, 1.

Chapter 13

205. "Indian Names to Be Revived by Power Company," *Atlanta Constitution*, December 23, 1923, C6.

206 . "Georgia Mountains and Lakes Linked," *Atlanta Constitution*, March 29, 1925, 15.

207. "Additional Power Given Consumers through Big Rains," *Atlanta Constitution*, October 27, 1925.

208. "Small Army of Trout Deposited in Lake," *Atlanta Constitution*, April 28, 1927, 3.

Chapter 14

209. Dallmier, "North Georgia Lakes."

210. McWhorter, "History of Seed Lake."

Chapter 15

211. "Rocky Mountain Recreation and Public Fishing Area," Trails.com, https://www.trails.com/tcatalog_trail.aspx?trailid=XFA050-003.

212. "History of Oglethorpe Power Corporation," http://www.fundinguniverse.com/company-histories/oglethorpe-power-corporation-history/.

Chapter 16

213. Woods, "TVA and the Three R's."

214. Ibid.

215. Pritchett, *Tennessee Valley Authority*, 43.

216. Ibid.

217. Vance, *Human Geography*.

218 Ibid.

219. "TVA—Building a Better Life for the Tennessee Valley," TVA, https://www.tva.com/About-TVA/Our-History/Built-for-the-People/Building-a-Better-Life-for-the-Tennessee-Valley.

220. Bennett, "As World War II Begins in Europe."

221. Ibid.

Chapter 17

222. Thompson, *Mountain Stories*, 8.

223. Ibid.

224. Ibid., 10.

225. Ibid., 11–12.

226. "Lake Blue Ridge," http://www.blueridgemountains.com/lake_blue_ridge.html.

Chapter 18

227. Thompson, *Mountain Stories*, 9.

228. "TVA—A Dam for All Seasons," TVA, https://www.tva.gov/About-TVA/Our-History/Built-for-the-People/A-Dam-for-All-Seasons.

229. Ibid.

230. Thompson, *Mountain Stories*, 14.

231. Ibid.
232. Wayne Nicholson, interview by John J. Russell, August 17, 2017.
233. Bennett, "As World War II Begins."
234. "Historical Hayesville," Historical Hayesville, http://historicalhayesville.blogspot.com/2011/12/history-of-lake-chatuge.html/historicalhayesville.blogspot.com/2011/12/history-of-lake-chatuge.html.
235. "National Archives at Atlanta," National Archives, https://www.archives.gov/atlanta/exhibits/exhibits-tva.html.

Chapter 19

236. Bennett, "As World War II Begins."
237. Rodman, "25+ Reasons Why Lake Nottely is Blairsville's Hidden Gem."

Chapter 20

238. Carter, "Flint River Integrity."
239. Ibid.
240. Ibid.
241. Ibid.
242. Ibid.
243. Ibid.
244. Ibid.
245. Ibid.
246. MODOC Stories, "Flint," YouTube, August 18, 2015, https://youtu.be/Wuhm8mHdx_4.

BIBLIOGRAPHY

About North Georgia. "Allatoona Pass." Accessed January 2, 2018. http://www. aboutnorthgeorgia.com/ang/Allatoona_Pass.

———. "Song of the Chattahoochee." Accessed October 21, 2017. http://www. aboutnorthgeorgia.com/ang/Song_of_the_Chattahoochee).

———. "Tallulah Gorge State Park." About North Georgia. Accessed January 18, 2018. http://www.aboutnorthgeorgia.com/ang/Tallulah_Gorge_ State_Park.

Administrator. "River Stories." Georgia River Network | Working Together for Healthy Rivers. Accessed January 2, 2018. https://garivers.org/experience-your-river/river-stories.html.

Allmon, Wiliam B. "The Desperate Battle of Allatoona Pass." Warfare History Network. Last modified October 20, 2015. http://warfarehistorynetwork.com/ daily/civil-war/the-desperate-battle-of-allatoona-pass.

Arlinda, S.B. "Daredevil Created Spectacle 45 Years Ago: July 18, 1970." *Atlanta Journal-Constitution*, July 18, 1970.

Atlanta Constitution. "Additional Power Given Consumers through Big Rains." October 27, 1925, 1.

———. "Found the Still but No Men." April 5, 1895, 3.

———. "General Corse." July 22, 1886, 4.

———. "Georgia Mountains and Lakes Linked in Gigantic Chain of Power." March 29, 1925, 15.

———. "Hold the Fort!" September 18, 1895, 5.

———. "'Indian' Names to Be Revived by Power Company." December 23, 1923, C6.

———. "Mountain Sliced at Tugalo Dam; Earth Trembles: Georgia Railway and…" May 2, 1923, 1.

———. "The Signal Service." November 6, 1886, 8.

———. "Sixes Gold Mine Has Rich Ore: The Company Has Been Capitalized At…" September 23, 1897, 9.

———. "Small Army of Trout Deposited in Lakes." April 28, 1927, 3.

———. "To Resume Work on Tugaloo Dam in North Georgia." January 1, 1922, 1.

———. "Town Is Built to House Labor at Tugalo Dam." July 6, 1922, 16.

Augusta (GA) Chronicle. "Falling Water Levels Expose Town Site." Accessed October 9, 2017. http://chronicle.augusta.com/stories/2002/09/03/met_350561.shtml#.Wcfuv8iGM2w.

Bailey, Ralph, Jr.; Paul E. Brockington, Charles F. Philips, Patricia F. Stallings, U.S. Army Corps of Engineers, South Atlantic Division, Mobile District, Brockington and Associates Inc. "History of the South Atlantic Division of the US Army Corps of Engineers, 1945–2011." U.S. Army Corps of Engineers, 2012. http://cdm16021.contentdm.oclc.org/cdm/ref/collection/p16021coll4/id/191.

Ballenger, Bruce P. *The Curious Researcher: A Guide to Writing Research Papers.* 8th ed. Boston: Pearson, 2015.

Banks, Rashida. "The Purpose of Russell Lake and How It's Different." U.S. Army Corps of Engineers Savannah District. Last modified May 29, 2013. http://balancingthebasin.armylive.dodlive.mil/2013/05/29/the-purpose-of-russell-lake-and-how-its-different.

Barber, Henry E. "History of the Savannah District, 1829–1989." U.S. Army Corps of Engineers, Savannah District, 1989, 419–34. Last modified 1989. http://www.sas.usace.army.mil/About/Divisions-and-Offices/Operations-Division/J-Strom-Thurmond-Dam-and-Lake/History.

Bartram, William. *Travels Through North and South Carolina, Georgia, East and West Florida, the Cherokese Country, the Extensive Territories of the Muscogulges or Creek Confederacy, and the Country of the Chactaws: Containing an Account of the Soil and Natural Productions of Those Regions Together with Observations on the Manners of the Indians: Embellished with Copper-Plates.* Philadelphia: James and Johnson, 1794. http://docsouth.unc.edu/nc/bartram/bartram.html.

———. *The Travels of William Bartram: The Naturalist Edition.* Edited by Francis Harper. Athens: University of Georgia Press, n.d. http://www.ugapress.org/index.php/books/travels_of_william_bartram.

Battey, George M. "Did You Know?" In *Prospectus of a History of Rome and Floyd County, State of Georgia, United States of America (including Numerous Incidents of More Than Local Interest) 1540-1922,* 490th ed., 490. Webb & Vary, 1922.

Bennett, Tom. "As World War II Begins in Europe, Three of Four Dams on the Hiwassee River Are Built…Hiwassee River Watershed Coalition." Hiwassee River Watershed Coalition. Last modified November 28, 2006. https://hrwc.net/as-world-war-ii-begins-in-europe-three-of-four-dams-on-the-hiwassee-river-are-built.

Bishop, W. Jeff. "Relocating Vann's Tavern." Trail of the Trail. Last modified October 17, 2009. http://trailofthetrail.blogspot.com/2009/10/relocating-vanns-tavern.html.

Blue Ridge Highlander. "Nottely River in the North Georgia Mountains." Accessed January 17, 2018. https://theblueridgehighlander.com/rivers_creeks_in_the_mtns/north_georgia/nottely_river.php.

Brown, Joseph M. *Mountain Campaigns in Georgia: Or, War Scenes on the W. & A.* Nabu Press, 2012.

Calhoon, Margaret Obear. "Georgia Power Company/Southern Company." *New Georgia Encyclopedia.* Last modified June 6, 2017. https://www.georgiaencyclopedia.org/articles/business-economy/georgia-power-companysouthern-company.

Carter, Jimmy. "Flint River Integrity As a Free Flowing Waterway Was Protected." *Brown's Guide.* December 10, 2017. http://brownsguides.com/flint-river.

Cartersville (GA) News. "In the Old Times: Rev. Abernathy Tells of Things of Long Ago, A Pioneer Citizen, Traveled Three Hundred Miles, Without Crossing a Railroad, Fording the Streams." March 16, 1905.

———. "Rev. Bard Abernathy Was Among Those Settling in Bartow After Indians Left." March 31, 1910.

Civil War Trust. "James Longstreet." Accessed January 18, 2018. https://www.civilwar.org/learn/biographies/james-longstreet.

Colonial America. "Old Tugalo Town." www.colonialamerica.com/site/map.cfm?primary_site_key=25DA8805-C7F5-8170-BE0488657CA1865C.

Conine, Brenda L. "Brenda Landers Conine." Facebook (blog). June 1, 2016. https://www.facebook.com/groups/97177545592/permalink/10157003794530593.

Coughlin, Robert David. *Lake Sidney Lanier: A Storybook Site: The Early History and Construction of Buford Dam.* 2nd ed. Atlanta, GA: RDC Productions, 1998.

Coulter, E. Merton. *Georgia Waters: Tallulah Falls, Madison Springs, Scull Shoals and the Okefenokee Swamp.* Athens: Georgia Historical Quarterly, 1965.

———. "Nancy Hart, Georgia Heroine of the Revolution: The Story of the Growth of a Tradition." *Georgia Historical Quarterly* 39, no. 2 (June 1955): 118–51.

———. *Old Petersburg and the Broad River Valley of Georgia: Their Rise and Decline.* Milledgeville, GA: Boyd Publishing, 1994.

Cowie, Gail. "Reservoirs in Georgia: Meeting Water Supply Needs While Minimizing Impacts." Southeast Aquatic Resources Partnership (SARP) River Basin Science and Policy Center Institute of Ecology, University of Georgia. Last modified May 2002. http://southeastaquatics.net/resources/pdfs/reservoirs%20in%20georgia.pdf.

Cox, Calvin. "Farmers Migrating En Masse to Cities." *Atlanta Constitution*, January 26, 1957, 4.

Cox, Dale. "Ghost of Allatoona Pass—Bartow County, Georgia." Explore Southern History. Last modified October 15, 2014. http://www.exploresouthernhistory.com/allatoonaghost.html.

Daily Times (Gainesville, GA). "Engineers Buy First Buford Lake Area Land." April 14, 1954, 1.

Dallmier, Kevin. "North Georgia Lakes." About North Georgia. Accessed January 17, 2018. http://www.aboutnorthgeorgia.com/ang/North_Georgia_Lakes.

Davis, Cindy. "Mindhole Blowers: 20 Facts About Deliverance That'll Make You...Well, You Know." Pajiba. September 2, 2017. http://www.pajiba.com/seriously_random_lists/mindhole-blowers-20-facts-about-deliverance-thatll-make-youwell-you-know.php.

Dickey, Christopher. *Summer of Deliverance: A Memoir of Father and Son.* New York: Simon & Schuster, 2010.

Ellet, E.F. "Nancy Heart." In *The Women of the American Revolution*, Vol. 1. New York: Baker and Scribner, 1850.

Elliott, Rita Folse. "The Pulse of Petersburg: A Multidisciplinary Investigation of a Submerged Tobacco Town in Georgia." PhD diss., Eastern Carolina University, 1988. http://www.ecu.edu/cs-cas/maritime/Rita-Folse-Elliott.cfm.

Estep, Tyler. "Just How Deadly Is Lake Lanier?" *Atlanta Journal-Constitution.* Last modified May 26, 2017. http://www.ajc.com/news/local/just-how-deadly-lake-lanier/UvRlc6bib6ufTuQzav5XEK.

Etowah Valley Historical Society. "EVHS Map Gallery." Last modified 2016. http://pangaea.kennesaw.edu/EVHS.

Explore Southern History. "Battle of Allatoona Pass—Bartow County, Georgia." Accessed October 15, 2017. http://www.exploresouthernhistory.com/allatoonapass.html.

———. "Ghost of Allatoona Pass—Bartow County, Georgia." Accessed October 15, 2017. http://www.exploresouthernhistory.com/allatoonaghost.html.

Fannin County Chamber of Commerce. "Lake Blue Ridge—Fannin County Chamber of Commerce—Blue Ridge, Georgia." Accessed December 7, 2017. http://www.blueridgemountains.com/lake_blue_ridge.html.

Farber, Stephen. "'Deliverance', How It Delivers." *New York Times.* August 20, 1972. http://www.nytimes.com/books/98/08/30/specials/dickey-delivers.html.

Flickr. "Huron Smith in Georgia." Accessed October 22, 2017. https://www.flickr.com/photos/field_museum_library/sets/72157624823183581.

Foster, A. "Notice of the Tockoa and Tullulah Falls in Georgia." *Georgia Courier* (Augusta), August 11, 1828, Vol. 3, No. 28. https://gahistoricnewspapers.galileo.usg.edu/lccn/sn82015765/1828-08-11/ed-1/seq-1/://.

FundingUniverse. "History of Oglethorpe Power Corporation." http://www.fundinguniverse.com/company-histories/oglethorpe-power-corporation-history.

Gardner, Sarah E. "Helen Dortch Longstreet (1863–1962)." *New Georgia Encyclopedia.* Last modified September 11, 2014. http://www.georgiaencyclopedia.org/articles/history-archaeology/helen-dortch-longstreet-1863-1962.

Genealogy Trails History Group. "History of Union County, Georgia." Accessed November 26, 2017. http://genealogytrails.com/geo/union/history.html.

Georgia Archives. "Rome, 1886. Flood of 1886. Broad Street Looking South from in Front of Masonic Temple Building. Note Men Paddling Down Street on Canoe." http://vault.georgiaarchives.org/cdm/ref/collection/vg2/id/5786.

Georgia Department of Natural Resources. "Lakes in Georgia, United States." Accessed October 5, 2017. http://www.lakesonline.com/USA/Georgia.

GeorgiaInfo. "History–Lake Hartwell." Accessed October 21, 2017. http://georgiainfo.galileo.usg.edu/topics/history/article/the-leo-frank-case/lake-hartwell.

Georgia Power. "North Georgia Hydro Group." Accessed October 21, 2017. https://www.georgiapower.com/docs/about-us/N.GA%20Hydro%20Group.pdf.

———. "North Georgia Lakes | Lakes & Recreation | Georgia Power." Accessed January 1, 2018. https://www.georgiapower.com/in-your-community/lakes-and-recreation/north/home.cshtml.

Georgia Public Broadcasting. "Nancy Hart: Rebel Heroine." http://www.gpb.org/georgiastories/stories/nancy_hart_story.

Georgia State Parks. "Tugaloo State Park." Last modified March 13, 2017. http://gastateparks.org/Tugaloo.

Gillespie, Deanna M. "'Revolutionize Life in the Chattahoochee River Valley': Buford Dam and the Development of Northeastern Georgia, 1950–1970." *Georgia Historical Quarterly*, no. 1 (2016): 405–40. http://georgiahistory.com/publications-scholarship/the-georgia-historical-quarterly/georgia-historical-quarterly-archive.

Gilliam, Kevin. "Tallulah Falls Returns for a Day." *Trains* 75, no. 11 (2015): 93. Accessed October 22, 2017, http://www.trainsmag.com.

Goff, John H., Francis Lee Utley and Marion R. Hemperley. "No. 52 Sixes." In *Placenames of Georgia: Essays of John H. Goff*, 143–46. Athens: University of Georgia Press, 2007. https://books.google.com/books?id=kqvy856lISUC&pg=PA143&lpg=PA143&dq=Sixes+or+Sutalle&source=bl&ots=sv4jvW9wL-&sig=iIsqwJylFQ2fgwGNtCJZZ5_DK2g&hl=en&sa=X&ved=0ahUKEwivmPnSvczbAhXDzFMKHTfCAa4Q6AEIQzAD#v=onepage&q=Sixes%20or%20Sutalle&f=false.

Golden, Randy. "Battle of Allatoona Pass." Our Georgia History. Accessed January 2, 2018. http://www.ourgeorgiahistory.com/wars/Civil_War/allatoonapass.html.

Gregory, Jeane. *An Archival and Field Survey of Selected Historic Cultural Resources, Allatona Lake, Georgia*. Fort Belvoir, VA: Defense Technical Information Center, 1984.

Hall, B.M., and M.R. Hall. "Third Report on the Water Powers of Georgia." Atlanta. GA: Byrd Printing. 1921. https://epd.georgia.gov/sites/epd.georgia.gov/files/related_files/site_page/B-38.pdf.

Hall, Leslie. "Hart, Nancy Morgan." In *Encyclopedia of the American Revolution: Library of Military History*. Vol. 1. Charles Scribner's Sons, 2006. http://link.galegroup.com/apps/doc/CX3454900714/UHIC?u=ereader_his_gale&xid=c16a9b63.

Harris, Joel Chandler. "Aunt Nancy." In *Stories of Georgia*, 69–80. New York: American Book Company, 1896. http://www.gutenberg.org/files/24728/24728-h/24728-h.htm.

Hart County Historical Society. "Our History." Accessed November 26, 2017. http://hartcountyhistoricalsociety.org/html/our_history.html.

Head, Joe. "The Civil War in Bartow County, The Battle of Allatoona Pass, Article 4." Etowah Valley Historical Society. Last modified November 16, 2017. http://evhsonline.org/archives/44481.

Historical Hayesville. "Historical Hayesville." Accessed December 7, 2017. http://

historicalhayesville.blogspot.com/2011/12/history-of-lake-chatuge.html/ historicalhayesville.blogspot.com/2011/12/history-of-lake-chatuge.html.

Historical Marker Database. "Richard B. Russell Dam Historical Marker." Last modified June 16, 2016. http://www.hmdb.org/marker.asp?marker=15876.

Hood, Mary. "The Tropic of Conscience." In *The New Georgia Guide*, edited by Georgia Humanities Council, 105–135. Athens: University of Georgia Press, 1996.

Hudson, Charles. *Knights of Spain, Warriors of the Sun: Hernando De Soto and the South's Ancient Chiefdoms*. Athens: University of Georgia Press, 1998.

Huff, Christopher A. "Hiawassee." *New Georgia Encyclopedia*. Last modified May 31, 2016. http://www.georgiaencyclopedia.org/articles/counties-cities-neighborhoods/ hiawassee.

Jones, Charles C. "Petersburg, Jacksonborough, Francisville, & C., &C." In *Dead Towns of Georgia*, 30–244. Abercorn, GA: Morning News Steam Printing House, 1878.

Kay, Terry. "Song of the Plowman's Dream." *Backroads Georgia* (Summer 2015).

Krakow, Kenneth K. "Petersburg." In *Georgia Place-Names*, 174–75. Macon, GA: Winship Press, 1999. http://www.kenkrakow.com/gpn/p.pdf.

Lake Allatoona. "Why Lake Allatoona Is Still Flooded." Last modified May 9, 2013. http://www.lake-allatoona.com/blog/why-lake-allatoona-is-still-flooded.

Lake Rabun. "Lake Rabun, History." Accessed January 8, 2018. http://lakerabun. com/Lake_Rabun/History.html.

Langford, Jim. "The Post-DeSoto Apocalypse in Northwest Georgia." Lecture, Etowah Valley Historical Society Lecture Series, 1903, Gold Dome Court House, November 9, 2017.

Lanier, Sidney. "About North Georgia." About North Georgia. Accessed November 26, 2017. http://www.aboutnorthgeorgia.com/ang/Song_of_the_ Chattahoochee.

Lavender, Rick. "A View of History: As Lanier Celebrates 50 Years, Residents Recall When the Lake Was Built." *Gainesville (GA) Times*. May 27, 2007. http:// gainesvillelegals.com/news/stories/20070527/localnews/175862.shtml.

Ledbetter, Jerald. "A Discussion of Joseph Caldwell's Late Archaic Stamp Creek Focus of Northwest Georgia." Society for Georgia Archaeology. Last modified October 10, 2007. http://thesga.org/2007/10/a-discussion-of-joseph- caldwell%E2%80%99s-late-archaic-stamp-creek-focus-of-northwest-georgia.

Longstreet, Augustus Baldwin. "XV." In *Master William Mitten, or, A Youth of Brilliant Talents, Who Was Ruined by Bad Luck*, 129. Macon, GA: Burke, Boykin, 1864. http://galenet.galegroup.com/servlet/Sabin?af=RN&ae=CY102184920&srcht p=a&ste=14.

"Lost Race Tracks." H.A.M.B. Last modified April 2, 2013. https://www. jalopyjournal.com/forum/threads/lost-race-tracks.449335/page-2.

Lowrey, J. "Dionysius Oliver." Find a Grave. Last modified January 17, 2010.

Manganiello, Christopher J. *Southern Water, Southern Power: How the Politics of Cheap Energy and Water Scarcity Shaped a Region*. Chapel Hill: University of North Carolina Press, 2017.

Martin, Christopher. "Earthly Evidence: Sacredness of Place in the Poetry of Byron

Herbert Reece." *Town Creek Poetry* (Fall 2012). http://www.towncreekpoetry.com/FALL12/CM_ESSAY.htm.

McCallister, Andrew. "'A Source of Pleasure, Profit, and Pride': Tourism, Industrialization, and Conservation at Tallulah Falls, Georgia, 1820–1915." Master's thesis, West Virginia University, 2002.

———. "Tallulah Falls and Gorge." *New Georgia Encyclopedia*. Last modified July 18, 2003. http://www.georgiaencyclopedia.org/articles/geography-environment/tallulah-falls-and-gorge.

McPhee, John. "Travels in Georgia." *New Yorker*, April 28, 1973. https://www.newyorker.com/magazine/1973/04/28/travels-in-georgia.

McWhorter, Howard, Jr. "History of Seed Lake." Seed Lake Association Inc. April 1999. http://www.seedlake.org/history-of-seed-lake.html.

MODOC Stories. "Flint." YouTube. August 18, 2015. https://youtu.be/Wuhm8mHdx_4.

Mooney, Diane. "Clayton-Mooney House, Allatoona, Allatoona Farm Now under a Lake, McMichen Gold Mine." Facebook (blog), http://evhsonline.org/bartow-history/places/allatoona.

Mountain View Group. "Big Bets (Full Program)—Southern Company." Vimeo. 2015. https://vimeo.com/97226639.

Muir, John. "Through the River Country of Georgia." Sierra Club. http://vault.sierraclub.org/john_muir_exhibit/writings/a_thousand_mile_walk_to_the_gulf/chapter_3.aspx.

National Archives. "National Archives at Atlanta." Accessed January 17, 2018. https://www.archives.gov/atlanta/exhibits/exhibits-tva.html.

New Georgia Encyclopedia. "Tallulah Falls and Gorge." Accessed November 26, 2017. http://www.georgiaencyclopedia.org/articles/geography-environment/tallulah-falls-and-gorge.

New York Herald. "The Latest War News." October 8, 1864. Accessed October 15, 2017. https://login.proxy.kennesaw.edu/login?url=https://search-proquest-com.proxy.kennesaw.edu/docview/505756901?accountid=11824.

New York Times. "From a Private's Diary." August 9, 1893, 17. Accessed October 15, 2017. https://login.proxy.kennesaw.edu/login?url=https://search-proquest-com.proxy.kennesaw.edu/docview/95045923?accountid=11824.

———. "Gen. Corse's Famous Signal." December 15, 1895, 29. Accessed October 15, 2017. https://login.proxy.kennesaw.edu/login?url=https://search-proquest-com.proxy.kennesaw.edu/docview/95309716?accountid=11824.

———. "Hero of Allatoona." April 26, 1896, 26. Accessed October 15, 2017. https://login.proxy.kennesaw.edu/login?url=https://search-proquest-com.proxy.kennesaw.edu/docview/1013637766?accountid=11824.

Official Guide to North Georgia and North Georgia Mountains. "Lake Chatuge | North Georgia." http://www.northgeorgia.com/lakes/lake-chatuge.

Old Macedonia Cemetery (Bartow County). "Bardy and Matilda Abernathy—

Old Macedonia Cemetery." Accessed November 11, 2017. http://www.oldmacedoniacemetery.com/abernathybardylarkin1.htm.

Osinski, Bill. "When War Woman Meets Tar Baby, Separating History from Myth Gets a Little Sticky." *Atlanta Journal-Constitution*, May 1997, 3:1.

Outdoor Activity Adventure Guides. "Nottely River Kayaking and Canoeing Guide: Brown's Guides." Last modified November 12, 2017. https://brownsguides.com/nottely-river-kayaking.

Ouzts, Clay. "Nancy Hart (ca. 1735–1830)." *New Georgia Encyclopedia*. Last modified December 17, 2016. http://www.georgiaencyclopedia.org/articles/history-archaeology/nancy-hart-ca-1735-1830.

———. "Petersburg." *New Georgia Encyclopedia*. Last modified May 31, 2016. http://www.georgiaencyclopedia.org/articles/history-archaeology/petersburg.

Parker, Amanda K. "Reservoirs." *New Georgia Encyclopedia*. Last modified April 25, 2005. http://www.georgiaencyclopedia.org/articles/geography-environment/reservoirs.

Pavey, Robert. "Drought-Lowered Reservoir Offers Glimpse of Lost City Petersburg." *Augusta Chronicle*. February 2, 2013. http://chronicle.augusta.com/news-metro-latest-news/2013-02-02/drought-lowered-reservoir-offers-glimpse-lost-city-petersburg.

———. "Falling Water Levels Expose Town Site." *Augusta Chronicle*. September 2, 2003. http://chronicle.augusta.com/stories/2002/09/03/met_350561.shtml#.Wcfuv8iGM2w.

"Power Dispatch and Protection Branch." Blue Ridge Hydroelectric Plant, *System Control News* no. 83, Blue Ridge, Georgia, 1975.

Pritchett, C. Herman. *The Tennessee Valley Authority: A Study in Public Administration*. Chapel Hill: University of North Carolina Press, 1943.

Rabun County Historical Society. "Lakes and Dams." Accessed January 18, 2018. http://www.rabunhistory.org/photo-gallery/lakes-and-dams/?page=3.

Reece, Chuck. "The Flint River Tells Stories." Bitter Southernor. Accessed December 28, 2017. http://bittersoutherner.com/video/flint/#.WkRLm9-nE2.

Remnick, David, Philip Bosco, Amy Irving, and Alton Fitzgerald White. "John McPhee: Travels in Georgia." In *Life Stories: Profiles from the New Yorker*, 161–93. New York: Random House, 2000.

Reynolds, George P., and Susan W. Walker. "Burton." In *Foxfire 10: Railroad Lore, Boardinghouses, Depression-Era Appalachia, Chair Making, Whirligigs, Snake Canes, and Gourd Art*, 163–77. New York: Anchor Books, 1993.

———. "The CCC." In *Foxfire 10: Railroad Lore, Boardinghouses, Depression-Era Appalachia, Chair Making, Whirligigs, Snake Canes, and Gourd Art*, 240–84. New York: Anchor Books, 1993.

———. "Clearing the Land." In *Foxfire 10: Railroad Lore, Boardinghouses, Depression-Era Appalachia, Chair Making, Whirligigs, Snake Canes, and Gourd Art*, 178–85. New York: Anchor Books, 1993.

———. "Folklore." In *Foxfire 10: Railroad Lore, Boardinghouses, Depression-Era Appalachia,*

Chair Making, Whirligigs, Snake Canes, and Gourd Art, 202–11. New York: Anchor Books, 1993.

———. "The Tallulah Falls Hotel Era." In *Foxfire 10: Railroad Lore, Boardinghouses, Depression-Era Appalachia, Chair Making, Whirligigs, Snake Canes, and Gourd Art*, 91–15. New York: Anchor Books, 1993.

———. "Tallulah Falls Railway." In *Foxfire 10: Railroad Lore, Boardinghouses, Depression-Era Appalachia, Chair Making, Whirligigs, Snake Canes, and Gourd Art*, 3–85. New York: Anchor Books, 1993.

Ritchie, Andrew Jackson. Sketches of Rabun County History, 1819–1948. Salem, MA: Higginson, 1948.

Roadside Georgia. "Rome, Georgia." http://roadsidegeorgia.com/city/rome.html.

———. "Towns County, Georgia, History, Resources, Links, and Events." http://roadsidegeorgia.com/county/towns.html.

Rodman, Sue. "25+ Reasons Why Lake Nottely Is Blairsville's Hidden Gem." 365 Atlanta Family. Last modified January 16, 2018. https://365atlantafamily.com/lake-nottely-2-3.

Roper, Daniel M. "A River Ran Through It." *North Georgia Journal* (Summer 1995).

Russell, Lisa M. "Hoke and Pauline Russell." YouTube. February 3, 1990. https://www.youtube.com/watch?v=EVD2hYpzxzc&feature=youtu.be.

———. *Lost Towns of North Georgia*. Charleston, SC: The History Press, 2016.

Sawyer, Gordon. *Northeast Georgia: A History*. Charleston, SC: Arcadia Publishing, 2001.

Scott, John Thomas. "Nancy Hart (ca. 1735– ca. 1830): Too Good Not to Tell Again." In *Georgia Women: Their Lives and Times*, 33–50. Athens: University of Georgia Press, 2009.

Sibbald, George. *Notes and Observations on the Pinelands of Georgia, Shewing the Advantages They Possess, Particularly in the Culture of Cotton Addressed to Persons Emigrating, and Those Disposed to Encourage Migration to This State; Together with a Plan of Emigration for Their Immediate Settlement*. Augusta, GA: William J. Bunce, 1801.

Sibley, Celestine. "Etowah Valley, Its Growth, Its Destruction, Its History." *Atlanta Constitution*, October 14, 1949.

Smith, Russell. *Lake Hartwell: The Great Lake of the South*. Greenville, SC: Backseat Publishing, 2007.

Smith, Sammy. "Ways to Make the Past a Story." Society for Georgia Archaeology. December 11, 2011. http://thesga.org/2011/12/ways-to-make-the-past-a-story.

Snell, David. "$15,000,000 Dam to Bring Ghost Town Back to Life." *Atlanta Constitution*, February 12, 1945.

South Carolina Lakes Database. "Lake Tugalo—Oconee County SC & Rabun County GA." Accessed November 26, 2017. http://southcarolinalakes.info/small-lakes/lake-tugalo-oconee-county-sc-rabun-county-ga.html.

Southeast Aquatic Resources Partnership (SARP). "Reservoirs in Georgia: Meeting Water Supply Needs While Minimizing Impacts." May 2002. http://southeastaquatics.net/resources/pdfs/reservoirs%20in%20georgia.pdf.

Staff Writer. "A Past Washed Away." *Augusta Chronicle*, August 23, 1998.

http://chronicle.augusta.com/stories/1998/08/23/met_236798.shtml#.WchnEciGM2w.

Stephens County, Georgia. "History." Accessed January 6, 2018. http://www.stephenscountyga.com/history.cfm.

Storey, Steve. "Tallulah Gorge Incline Railway." Georgia's Railroad History and Heritage. Accessed October 22, 2017. https://railga.com/tallugorge.html.

Sutherland, Robert. "History at Lake Allatoona." Lake Allatoona. Accessed October 12, 2017. https://lakeallatoona.com/about/history.

Swancer, Bruce. "Mysteries and Death at Georgia's Cursed Lake." Mysterious Universe. Last modified December 4, 2015. http://mysteriousuniverse.org/2015/12/mysteries-and-death-at-georgias-cursed-lake.

Tennessee Valley Authority. "Blue Ridge Reservoir." https://www.tva.gov/Energy/Our-Power-System/Hydroelectric/Blue-Ridge-Reservoir.

———. "Building a Better Life for the Tennessee Valley." Accessed January 17, 2018. https://www.tva.com/About-TVA/Our-History/Built-for-the-People/Building-a-Better-Life-for-the-Tennessee-Valley.

———. "Chatuge." Accessed November 26, 2017. https://www.tva.gov/Energy/Our-Power-System/Hydroelectric/Chatuge-Reservoir.

———. "A Dam for All Seasons." Accessed January 18, 2018. https://www.tva.gov/About-TVA/Our-History/Built-for-the-People/A-Dam-for-All-Seasons.

———. "Nottely." Accessed November 26, 2017. https://www.tva.gov/Energy/Our-Power-System/Hydroelectric/Nottely-Reservoir.

———. "The Quiet Beauty of Nottely." Accessed November 26, 2017. https://www.tva.gov/About-TVA/Our-History/Built-for-the-People/The-Quiet-Beauty-of-Nottely.

———. "Richard B. Russell Dam and Lake, (formerly Trotters Shoals Lake), Savannah River (GA, SC)." Environmental Impact Statement. 1974.

Thompson, Kathleen. *Blue Ridge*. Blue Ridge, GA: Thompson Publishing, 2016.

———. *Mountain Stories: Appalachian Tales, Interesting Place, History, Heroes, and Humor.* Blue Ridge, GA: Thompson Publishing, 2016.

Tiger Pregame Show. "December 31st Clemson Historic Picture of the Day." Last modified December 31, 2016. http://tigerpregameshow.blogspot.com/2016/12/december-31st-clemson-historic-picture.html.

Towns County Historical Society. "Old Rock Jail Museum." Accessed November 26, 2017. http://townscountyhistory.org/old-rock-jail-museum.

Townsend, Billy. *History of the Georgia State Parks and Historic Sites Division*. Atlanta: Georgia State Parks and Historic Division, 2001.

Trails.com. "Rocky Mountain Recreation and Public Fishing Area." Accessed January 16, 2018. https://www.trails.com/tcatalog_trail.aspx?trailid=XFA050-003.

Tugaloo Corridor. "Tugaloo." Accessed January 17, 2018. http://www.tugaloocorridor.org/historical-sites.

U.S. Army Corps of Engineers, Savannah District. "Brief History of the Corps:

Introduction." Accessed October 12, 2017. http://www.usace.army.mil/About/History/Brief-History-of-the-Corps/Introduction.

———. "Hartwell Dam and Lake: History." Accessed November 26, 2017. http://www.sas.usace.army.mil/About/Divisions-and-Offices/Operations-Division/Hartwell-Dam-and-Lake/History.

———. "History." Accessed October 21, 2017. http://www.sas.usace.army.mil/About/Divisions-and-Offices/Operations-Division/Hartwell-Dam-and-Lake/History.

———. "J. Strom Thurmond Dam and Lake." Last modified October 1, 2010. http://www.sas.usace.army.mil/About/Divisions-and-Offices/Operations-Division/J-Strom-Thurmond-Dam-and-Lake/History.

———. "Pumpback and Its Effects on Thurmond Lake." February 27, 2013. http://balancingthebasin.armylive.dodlive.mil/2013/02/27/pumpback-2.

———. "The Purpose of Russell Lake and How It's Different." Last modified May 29, 2013. http://balancingthebasin.armylive.dodlive.mil/2013/05/29/the-purpose-of-russell-lake-and-how-its-different.

———. "Savannah District Hartwell Dam and Lake History." Accessed January 17, 2018. http://www.sas.usace.army.mil/About/Divisions-and-Offices/Operations-Division/Hartwell-Dam-and-Lake/History.

———. "Savannah District Hartwell Dam and Lake Introduction." Accessed January 17, 2018. http://www.sas.usace.army.mil/About/Divisions-and-Offices/Operations-Division/Hartwell-Dam-and-Lake/Introduction.

———. "Water Management 101." Accessed November 26, 2017. http://balancingthebasin.armylive.dodlive.mil/water-management-101.

U.S. War Department. *Engineer Soldier's Handbook*. Digital Library. June 2, 1943. https://digital.library.unt.edu/ark:/67531/metadc28313.

———. "Insignia." In *Engineer Soldier's Handbook*. Digital Library. June 2, 1943. Accessed October 12, 2017. https://digital.library.unt.edu/ark:/67531/metadc28313.

Vance, Rupert Bayless. *Human Geography of the South: A Study in Regional Resources and Human Adequacy*. New York: Russell & Russell, 1968.

Vogt, Larry. "Lovingood's Bridge/Victoria/Victoria's Landing." In *Hidden History of Lake Allatoona: The Sixes, Cherokee Mills, Little River Area of Cherokee County, Georgia*. 2nd ed. Dautzenlein Publications, 2013. Kindle.

WGCL Digital Team. "Is Lake Lanier Haunted? CBS46 Takes a Look." Atlanta, GA News, Weather, Events, Photos | Georgia - CBS46 News. Last modified October 31, 2017. http://www.cbs46.com/story/36723758/is-lake-lanier-haunted-cbs46-takes-a-look.

Wild River. Directed by Elia Kazan. 1960. You Tube, 1960. Film. Stars Lee Remick and Montgomery Cliff.

Williams, Philip Lee. "Summers on the Lake." *Atlanta Magazine*. June 1, 2013. http://www.atlantamagazine.com/travel-other/summers-on-the-lake.

Woodall, Barbara T. "The Deliverance Stigma." It's Not My Mountain Anymore.

Last modified 2012. http://itsnotmymountainanymore.com/deliverance-stigma.

Woods, Edward A. "TVA and the Three R's." *Journal of Educational Sociology* 8, no. 5 (1935): 292–93.

World Fishing Network. "Five Interesting Facts About Lake Hartwell." Accessed November 26, 2017. http://www.worldfishingnetwork.com/stories/post/five-interesting-facts-lake-hartwell.

Wright, Wade H. *History of the Georgia Power Company: 1855–1956.* Atlanta: Georgia Power Company, 1957.

INDEX

O

Oak Hill Cemetery 37, 41, 181
Old Macedonia 34
Oliver, Dionysius 63

P

Perdue, Sonny 26
Petersburg 60
Petersburg boat 64

R

Reece 14
reservoirs 25
Revolutionary War 63, 69
Richard B. Russell Lake 95
Rome, Georgia 58

S

Savannah River 61, 63, 64, 65, 67, 68
Seventh Illinois Infantry Regiment, the 46
Sherman, William Tecumseh 45
Sibbald, George 61
Sibley, Celestine 57
Sixes 55
Stinchcomb Cemetery 69
Stroop, Moses 37, 39, 61
Sutallee 55

T

Tallulah Falls 98, 99, 100, 104, 106
Tallulah Gorge 12, 13

Tennessee Valley Authority (TVA) 23, 25, 125, 126, 143, 145, 149
"The Song of the Chattahoochee" 10
tobacco 64
Tourtellotte, Colonel John 46

U

UGA River Basin Science and Policy Center 25
U.S. Army Corps of Engineers 25, 31, 32

V

Victoria 56, 57

W

Watershed Protection and Flood Prevention Act of 1954 25, 26
Wendell 14
Western Atlantic Railroad (W&A) 39, 42
Whitney, Eli 66
Wilkes County 63
Williams, Philip Lee 108
Winchester rifles 47
Woodall, Barbara 13
World War II 69
Wright, Sir James 25

Y

Yonah, engine 40

ABOUT THE AUTHOR

Lisa Russell is a member of the Society for Georgia Archaeology, Bartow History Museum and Etowah Valley Historical Society. She earned her master's in professional writing from Kennesaw State University. When Lisa is not teaching at Georgia Northwestern Technical College or Kennesaw State University, she can be found exploring North Georgia through a micro-historic lens.